REBECCA CAHILL ROOTS

Modern Lettering

A GUIDE
TO MODERN CALLIGRAPHY
AND HAND LETTERING

BATSFORD

FOR MY DARLINGS TALL AND SMALL, D & R x

First published in the United Kingdom in 2017 by
Batsford
43 Great Ormond Street
London
WC1N 3HZ

An imprint of Pavilion Books Company Ltd

ISBN 978-1-84994-447-2

A CIP catalogue record for this book is available from the British Library.

10 9 8 7 6 5 4 3 2 1

Reproduction by Mission Productions Ltd, Hong Kong
Printed and bound by 1010 Printing International Ltd, China

This book can be ordered direct from the publisher at
www.pavilionbooks.com

Contents

Hello to you!

If you have picked up this book to have a peek then I suspect that, like me, you have an inkling of the kind of magic that can be made by putting pen to paper.

When my grandmother passed away, we were clearing out her belongings and discovered a shoebox full of old letters, cards and invitations, including her 21st birthday cards from childhood friends, new baby congratulations and letters from her husband-to-be. It was one of the first times I'd thought of her as a best friend, a new mother, or a girlfriend (saucy!). These precious records reminded me of how powerful handwritten correspondence can be, and it made me wonder: what will be left behind for our grandchildren in our increasingly digitized world?

I fell in love with hand lettering in my teenage years, spending hours creating notebook covers with my current crush's name emblazoned all over the front in decorative writing. Having learnt the basic rules of traditional Western calligraphy, I started to find ways to bend those rules and bring my own style to the glorious classic letterforms. Over the past few years, hand lettering has seen a resurgence alongside the interest in artisan products and traditional crafts. The unique nature of each piece, created by one hand in one precious moment, counteracts the impersonal nature of text messages, emails and tweets.

I am fascinated by the power of a handwritten card or letter, and while researching this book I stumbled across some great historic letters and etiquette advice that I will share with you along the way.

Through my own work and by teaching workshops, I have seen what a relaxing and meditative art form calligraphy can be. So whether you've decided to try hand lettering to learn a new skill, for relaxation, or for a special project such as your wedding, this book has been created to act as a little pen pal along the way. It will guide you through a range of basic skills, knowledge about materials, lettering practice, and ideas for projects.

But most of all, I hope it ignites a little inky passion in you that allows you to put your mark on the world in your own unique way.

Rebecca x

A life in letters

When was the last time you sat down and handwrote a letter? I'm not talking about a quick scribble in a colleague's birthday card at work, or a message to stick on the fridge; I mean a meaty, info-filled, let's catch up, here are some reasons you are marvellous, RSVP kind of a letter? It is increasingly easy for us to get by without having to use handwriting at all.

For those of us who still remember the feeling of cramp in the hands while hurriedly trying to scribble down facts about Dickens' characters for their English exams, this may come as a relief. But for many of us, digital correspondence just isn't quite enough.

Do you have a shelf full of beautiful notebooks at home but still manage to justify buying another one when you're in a bookshop or stationers? A favourite pen that you really don't like other people borrowing? Do you still skip towards your doormat when you hear the post arrive during your birthday week? Hurrah, you're one of us! Welcome to the family.

Putting pen to paper has been an important part of my life since childhood. Writing our thank-you notes after Christmas was a serious business in our house. We'd all sit around the kitchen table on 27 December with lashings of paper and the new pens we'd found in our stockings (how did Father Christmas know?). We made sure to personalize each note to describe the favourite features of our new microscope set or lockable diary and decorate the envelope leaving only just enough room for a legible address. I didn't know it then, but I now realize that my mum had orchestrated a lasting love affair with correspondence.

The discovery that you could have a pen pal from another country was as if someone had told me a fantastic and important secret. Carefully penning, decorating and addressing a letter to France, Poland or Canada filled me with excitement – almost as much as receiving one in return.

I first discovered calligraphy and decorative script in an old book of my dad's about *The Book of Kells*. This is an illuminated manuscript, created in around AD 800, detailing the Gospels and the New Testament in Latin. Each page features a lavish illustration accompanied by elaborate Western calligraphy, written on parchment using iron gall ink. I spent hours copying pages from it, tearing up

tin foil and sweet wrappers to make my own versions of the intricate illustrations and script.

Some years ago, I taught myself a basic Gothic calligraphy alphabet with the help of a book from the library, and began to practise meticulously. There is a majesty and rhythm to the Gothic style of calligraphy (more on this later) that creates a beautiful formal script, but for me, the constant need to make each letterform match a predetermined size, angle and shape felt quite limiting.

Inspired by the new trend for hand lettering that really picked up pace at the beginning of the 21st century, I started to explore more expressive lettering forms and experimented with a pointed pen. It was instantly clear that this nib allowed me to be far more expressive and free with my lettering. Using the Copperplate calligraphy letterforms as a basis, I have developed my own unique style, but continue to experiment with different inks, paints, paper and alphabets to continue my learning. I complement my calligraphy practice with the use of hand-lettered fonts that explore block letters, where the letters do not use cursive script but are mostly unconnected.

In 2014 I founded Betty Etiquette, a stationery brand and design studio in London. I am extremely lucky to now spend my days in the studio designing stationery products, wedding invitations and hand lettering for magazine editorial work. But my most precious days are the ones where I get to share my love of hand lettering by teaching workshops. From Liberty London to the Victoria and Albert Museum, it has been very exciting to see a brand-new set of people at each workshop re-engaging with their handwriting. It is fascinating to follow their development over weeks and months as they share their practice on social media, even if I am slowly doing myself out of a job!

I have used all I've learnt through teaching these workshops to create this book – all the questions, mistakes, frustrations and ultimately the achievements of my inky recruits.

Where did the modern lettering trend come from?

We take the huge quantity of books, newspapers and magazines published each year for granted. It is almost unimaginable now to think that at one time important information could only be shared by someone meticulously writing and then copying each version of a book.

Western hand lettering as we know it today has slowly evolved from the systems of symbols and shapes originally used by three main cultures – the Sumerian, Egyptian and Chinese – as systems of visual communication. Simple, angular line pictures or symbols were etched into stone, wet clay and wood to represent an image.

The Egyptians began to use papyrus and brushes made from reeds in around 2400 BC. This new writing material was smooth and allowed ink to flow more freely on it. This led to the symbols becoming more rounded, less angular and more detailed.

The ancient Romans were among the first people to really get to grips with how to have a good gossip and seal a deal in writing. Having conquered Greece, the Romans adopted many aspects of Greek culture, including an alphabet. These graceful but powerful capital letters began to appear on structures all over the Roman Empire. But carrying around a large lump of rock and tools to carve letters was not a great way to tell your wife you were going to be home late.

The writing style that developed from this period, Old and New Roman cursive, wasn't very easy to read, so a new pen with a broad nib was developed and a new font called Uncial began to be used. As the Roman Uncials became more widely used, letters became less formal and began to be run together to save time. This was the beginning of what we now recognize as our lowercase alphabet in Europe and America.

Spoiler alert! Then the Roman Empire fell and there was suddenly no principal place in which handwriting development could be centralized. All over Europe, literacy was developing at different rates. In the 8th century, the Emperor Charlemagne, ruler of the Frankish kingdom, ordered an English monk to begin the process of standardizing lettering for people to copy. This included a large uncial (capital letter) being used at the beginning of a sentence, spaces between words, and the use of punctuation. The lowercase letters also started to have ascenders (the parts that go up on a letter, such as 'b', 'h' and 't') and descenders (the parts that go down below the other letters on 'g', 'j' and 'q', etc.). This script was called Carolingian Minuscule.

In the mid-1400s, something happened that would change the development of handwriting forever. Johannes Gutenberg, a German blacksmith, invented a printing press that had moveable type, allowing the mass production of books. This was not only an extremely clever mechanical invention; it was also key in bringing affordable literacy to the masses.

The development of copperplate engraving came next, in the 16th century, enabling finely drawn script with thick and thin strokes to be reproduced in printing. The term Copperplate calligraphy, taking its name from the copper plates with which it was printed, includes many different types of script based on these original engravings. These alphabets were simple letterforms, but the basic strokes were brought to life by luxurious flourishes and sometimes featured animal or floral illustrations. The ability to produce this elegant script became something of a status symbol: this style of writing began to be taught in British schools, eventually spreading throughout the British Empire.

In the United States, Platt Rogers Spencer developed a new style, Spencerian Script, in the 1850s. He was a man on a mission to find a way to write more quickly so that he could speed up business and personal correspondence. He created Spencerian Script, with its distinctive oval-shaped letters, and founded a school to teach this new writing style. It quickly became the standard style across the US. You can still see the influence of the Spencerian Script today in the Coca-Cola logo, which was created in the late 19th century.

Many of the modern calligraphy and lettering styles that are being created today are based on Copperplate calligraphy styles or Spencerian Script alphabets. It's fascinating to see the journey the letterforms we will be using have gone on. It fills me with an appreciation for the skill, dedication and importance of good penmanship and the way in which it has been an integral part of the development of the Western world.

Handwritten fonts

In this book, I share my core modern calligraphy alphabet, which I use as a basis for my own work, and a selection of other letterforms that you can start experimenting with using your pointed pen. These fonts are all cursive (featuring joined-up letters) to create a sense of flow and the aesthetic of the modern calligraphy style.

We will also explore other hand-lettering styles that you can use to complement your modern calligraphy. This style of handwritten font is extremely popular in magazines, for film graphics, and is even used on the labelling of food and drink products. They can be created using your pointed pen, but we'll also look at how to use brush pens, fine liners and paintbrushes to see how they can add drama and personality to your lettering.

Writing has gone on an extraordinary journey to where you and I are lucky enough to have the freedom and access to education to practise it as a hobby. The Roman scribes, Emperor Charlemagne, Johannes Gutenberg, Platt Rogers Spencer and all the great penmanship masters who put pen to paper before us, we salute you!

INKY ANTICS

THE BENEFITS OF HANDWRITING

———————

It is not just the wholesome feeling you get inside from putting pen to paper; there are cognitive benefits to handwriting that simply cannot be emulated by digital devices. Researchers have shown that learning to write by hand has a great influence on the development of our brains and how we learn:

- Handwriting can boost creativity and imaginative thinking.
- It improves coordination.
- Children who learn to write by hand also learn to read faster.
- It can help to calm the mind and make you less anxious.
- It improves your memory.
- It can help keep our brains agile in older age.
- It uses much more of your brain than digital devices.

So when you are practising your lettering, you are not only working towards mastering a new skill but also giving your brain a boost at the same time.

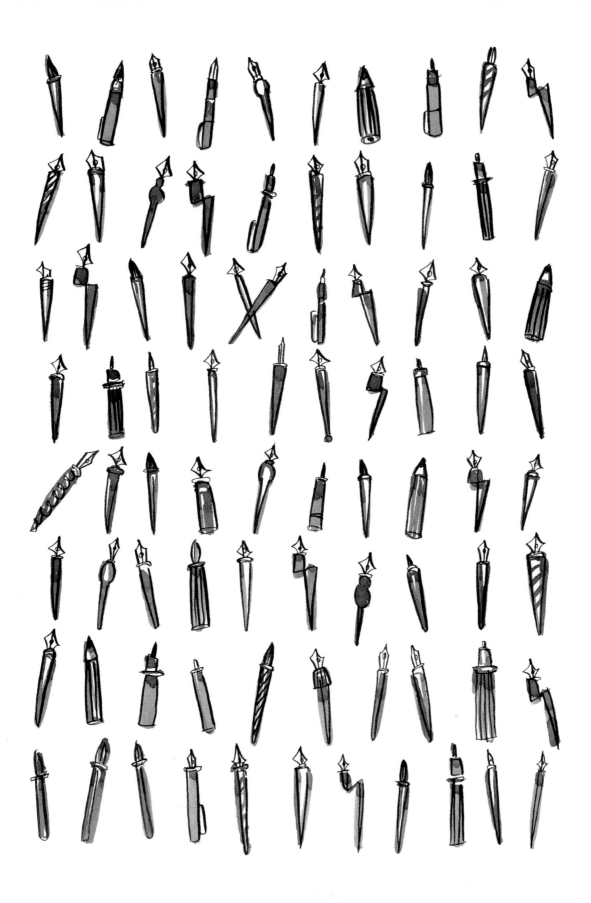

getting started

Before we get our hands on that tempting little bottle of ink, let me tell you a bit more about how to use this book. If you're anything like me, you will want to turn straight to the alphabet section (pages 40–93) and see what your name looks like when created with a pointed pen. It is this crafty excitement that has led to a series of disastrous half-finished crochet and embroidery projects currently hidden in the back of my studio cupboards.

We've all been writing since we were tiny, so it might feel as if we could just launch in and get cracking. However, having taught lots of new recruits in my workshops, I have seen how this can actually slow down the process. The hurried handwriting we use for everyday shopping lists and a colleague's birthday card is a world away from the beautiful hand lettering you will be learning to master. The art of modern lettering asks you to engage with your handwriting in a new way so you think about your writing as a picture, alongside being an informative piece of text.

The following chapters will guide you through easy-to-use introductions to your materials and letter formations. We will work through mark-making practice exercises to help you get to grips with your ink and nib. You will find alphabet examples to get started on, and when you have cracked connecting letters we will look at how to apply your new skills to a range of creative projects. When you can confidently use a pointed pen and ink, we will look at brush pens and paintbrushes to see how they can create different lettering styles.

By the end of the book you'll be penning the most beautiful thank-you cards in town and running out of surfaces in your house to decorate with your new skills.

So, before we begin:

- Gather together the materials listed in the Basic Toolkit section on page 14.
- Find somewhere comfortable enough that you can sit and work for a few hours. Ideally you will be working at a table, sitting on a stool or towards the edge of a chair close enough to enable you to lean over your work.
- Make sure you have a completely flat and dry surface to work on.
- Take off any large watches or bracelets and roll back your sleeves.

Finally, and most importantly, pour yourself a big cup of tea, select your biscuit of choice… and let's get started!

The basic toolkit

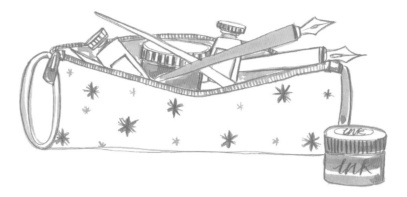

In the first half of this book, we are going to focus on mastering the modern calligraphy style with a pointed pen, also known as a dip pen, before we experiment with other hand-lettering effects. To get started you need relatively few items: a nib, a pen holder, ink and paper. We're going to start working with black ink on white paper. Once you have mastered the letter formations, we'll start to add more materials and techniques.

The materials that each calligrapher or lettering artist uses can be very different. It is like buying a sofa: you sit down on many different styles, but there will be one that is perfect for your posterior that might be really uncomfortable for the next person who tries it. There are hundreds of styles of nibs, ink, pen holders and paper out there; experienced calligraphers will have tried out many different kinds to find their perfect fit. Over the next few pages, I have suggested a selection of materials to get you started. As you become more confident, you can experiment to find your own perfect kit.

One thing that I have found is that you need to invest in good-quality materials. Although it can be tempting to pick up a cheap starter kit to experiment with, the quality of the nibs will make it much harder for you to conquer the letterforms and you are more likely to become frustrated or give up. Take the time to seek out trusted supplies to help you progress more quickly. We are now lucky enough to have great calligraphy shops available to us at the touch of a button (one type of online communication I do applaud!). All the items I discuss in this section are available in art shops or specialist stores online. It's a real joy to receive a parcel full of inks or new nibs in the post, so get researching and stock up on some basics to get started.

Nibs

These little magic-makers come in a vast range of sizes, strengths and shapes, but what do they actually do and how are they different from a regular fountain pen or ballpoint? For modern calligraphy, you will be using a pointed nib that you will dip into a pot of ink, repeating this action each time the ink runs out. The average fountain pen or ballpoint pen you pick up and use has a reservoir of ink inside the pen that allows you to write continuously for weeks on end until it runs out. These types of pens have a fixed nib that can create only one type of thickness of line and has very little flexibility. Modern lettering requires a flexible metal nib that allows you to vary the pressure you apply to it when on the paper.

At my workshops, participants often say that they expected the nibs to have a slanted or flat end. You might even have tried calligraphy before using felt-tip versions of these pens that create thick, dark strokes and angular lines. These nibs are called broad or chisel-edge nibs, and must be held at a constant angle horizontally to allow the ink to flow through. They are used for writing styles such as Gothic Black and Carolingian Minuscule – letterforms from which the modern styles were originally developed.

To create your lettering masterpieces we will be working with a pointed nib. This nib can produce both the delicate, hairline upstrokes and the heavier, thicker downstrokes that are needed to create a modern calligraphy style. In the diagram on page 16 we'll have a look at the anatomy of a pointed nib.

Down the centre of the nib there is a little slit that separates two pointed sections of metal called the tines. When the nib is placed on to the paper and a little pressure is applied to them, they separate slightly. It is through this gap that the ink flows; the more pressure you apply, the more ink can make its way between the tines to the paper. Increasing pressure to the nib also creates a thicker line as the tines physically separate further. The ability to control the change in pressure from heavy to light is key in being able to form the modern lettering alphabets.

Nibs come in a variety of metals and shapes: some are soft and flexible; some are hard and have very little give in them. In our everyday handwriting, we all put a different amount of pressure on the paper on which we are writing. Perhaps you are the kind of person

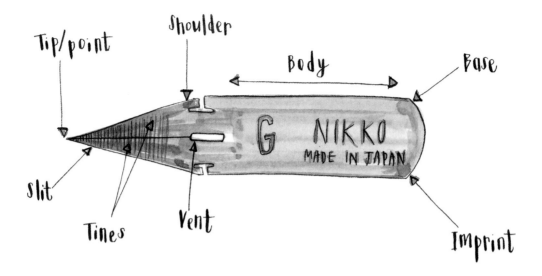

Tip/point · Shoulder · Body · Base · Slit · Tines · Vent · Imprint

G NIKKO
MADE IN JAPAN

who delicately tickles the paper and sometimes has to go over a word twice to make it visible; conversely, you might push quite hard on the paper and almost see the words traced through on the page underneath. Neither of these approaches is better or worse for modern lettering: you just need to find a nib that works for your writing style.

I recommend the Nikko G as a good all-round beginner's nib. This is a chrome-plated nib originally designed for manga drawing, but is perfect for modern lettering too. It is a great nib to start with as it allows good flow onto the paper but doesn't pool the ink or snag on the paper too much. It will allow you to create beautiful, consistent lines and start to feel confident with how and when to use pressure to create the letterforms.

When you have made good friends with the Nikko G, buy yourself a selection of some of the other nibs listed opposite and play around with them. You'll soon find that you love some and loathe others. Try the Brause 361 Steno (Blue Pumpkin) or the Zebra G nib to see what kind of effect they have on your lettering. To identify a type of nib, examine the lettering on the top of the nib between the vent and the base; the make or number is engraved into the metal.

HOW TO PREPARE YOUR NIBS

When your nibs arrive, you need to treat them like a teenager back from a muddy outdoor music festival. They need to be unpacked, looked over and scrubbed clean. Nibs come out of the factory with the manufacturer's oil on them to stop them rusting on their journey to your desk, but this film can prevent your ink from running through the nib properly.

There are two ways to get your nibs ink-ready: the scrubbing method and the flame method. To prep your nibs using the scrubbing method, use the rough side of an old washing-up sponge or an old toothbrush and scrub the nib using warm water. Make sure you dry your nib thoroughly when you have finished. To use the flame method, run the nib through a candle or lighter flame for a few seconds on each side. You may see some discolouration on the nib, but this is normal and won't affect the way your ink flows through it. Be careful using the flame method, as the nib will get hot. You may find it easier to prep your nibs while they are in the pen holder, as it is easier to control that way.

Warning: it is not advisable to use the flame method on teenagers returning home from a muddy music festival!

HOW TO CLEAN YOUR NIBS

To give your nibs the longest lifespan and ensure the ink flows well when you are using them, it is good practice to clean your nibs and nib holders after every use. Ink will dry quickly on your nib when it's not in use and can get stuck between the tines. You'll soon find that this clogs the flow of ink and stops you from writing smoothly.

Non-waterproof inks can be removed easily with a little warm water and washing-up liquid, but for waterproof ink you need to invest in some pen-cleaning fluid from an art store. Make sure you dry your nibs thoroughly to prevent them rusting. I use an old muslin cloth or some thick paper towel in the studio. Do not use a cloth or napkin that is dusty or has fibres that come off easily on the nib as you are cleaning it. These tiny threads can get stuck in the tines and can leave hairline ink marks on your lettering.

SHOPPING LIST

Nikko G nib to start with.
Then invest in a selection
of nibs to experiment with,
including Zebra G, Gillott
303, Brause 361 Steno (Blue
Pumpkin) and Hunt 22.

INKY ANTICS

WRITING SYSTEMS AROUND THE WORLD

Although I have briefly looked at the development of writing in the West in this book, there are many magical versions of hand lettering used around the world to explore.

The Chinese writing system uses a pictorial script called characters. There are tens of thousands of Chinese characters, although most people use only about 4,000 of these in their day-to-day correspondence. Some characters can be traced back to 4000 BC. The characters are part of the most widely used writing system in the world by number of users. Traditionally, Chinese characters are written in columns with characters ordered from top to bottom and running from right to left.

Arabic calligraphy is formed from the Arabic alphabet developed from the Nabataean script, made up of 28 cursive letterforms written from right to left. Unlike many Western alphabets, there are no upper- and lowercase letters; instead, a series of dots are used above and below the letterforms to distinguish between shapes that look similar. The historic development of Islamic calligraphy is strongly tied to the Qur'an and as such has become a highly popular form of artistic expression. A pen made from bamboo or reeds was traditionally used on papyrus, and coloured inks were popular to highlight the most important sections.

Ancient Indian calligraphy was most commonly used for religious texts. Each religion would have a calligraphy specialist within its communities to reproduce scriptures with intricate illustrations. In the Middle Ages, calligraphers throughout Southeast Asia would use Brahmic or Indic script, which was written from left to right. In many parts of India, palm leaves were traditionally used to write on as they lasted for centuries.

These are just a few examples of the beautiful hand lettering that developed at the same time as the letterforms we will be working with. Taking time to explore other cultures through the history of their writing might inspire you with exciting ideas for your own lettering practice.

Pen holder

A pen holder is what turns your nib from something that looks as if it belongs in an operating theatre into something that looks more recognizable for writing. Pen holders come in plastic, wood, glass or metal. Some have cork grips or are shaped to fit your hand. There are two basic styles of holder: straight or oblique. The straight holder simply holds your nib in line with the pen – this is the one I use day-to-day in the studio, as it allows me to produce the different angles needed for modern lettering shapes. The oblique holder was originally designed for right-handed calligraphers to achieve a better angle when writing Copperplate calligraphy. If you fall in love with this style or end up designing your own script that is on a constant slant, invest in an oblique holder to see how it can support your writing.

To get started, I recommend buying a standard round plastic or wooden pen holder. This style of pen holder is great for both right- and left-handers and will fit with all the nibs I have recommended in your shopping list. Pen holders can be cleaned using a sponge and warm water. If you're using a wooden pen holder, be careful to dry the holders properly after washing them to prevent water getting in and cracking the stems. We'll learn how to fit your nibs to your pen holder in the following chapter.

SHOPPING LIST

One or two standard round plastic or wooden pen holders.

Ink

Now we're getting to the good stuff! What are we going to use to bring our lettering to life? Ask any calligrapher or lettering artist what their favourite ink is and you'll get a different answer every time. For modern lettering, you can use a range of the pre-mixed professional-grade inks on the market. As you gain confidence in your practice you can start to mix your own from gouache or watercolour paint (more on that later).

One of my favourite inks, and the one I use with my workshop participants, is Higgins Eternal. This is a deliciously smooth, rich black ink that won't bleed too much on your paper and will help you achieve good definition between your thick and thin strokes. It is a great ink for beginners, and one bottle will go a long way as you are learning. Avoid waterproof inks while you are starting out. They are generally thicker, clog your nib more easily, and the weight of the ink can be hard to get used to when you need to concentrate on your strokes.

Throughout the history of calligraphy, different cultures have developed recipes for inks using weird and wonderful ingredients, including bone, carbon, fish, soot, nuts and animal fat. Iron gall nut ink, developed in the 5th century, is still used by many calligraphers today. It has a unique brown-black or purple-black tone that gives it a fairy-tale feel. It is fun to experiment with for special projects once you have mastered the basics. We will be working with black ink as we learn the basic letterforms as it is slightly more forgiving, but eventually you can move on to coloured inks on coloured papers. I love using delicious combinations like white ink on dark charcoal paper or copper ink on navy card.

The inks I have recommended can be used straight from the pot they come in. If you buy larger quantities of ink, decant a little into a small jam jar or plastic pot with a screw-top lid. This will prevent your large bottle of ink from being in contact with the air for too long, and it is almost impossible to judge how far to dip your pen into a large bottle of ink. Store inks away from heat sources and always replace the lids tightly when not in use.

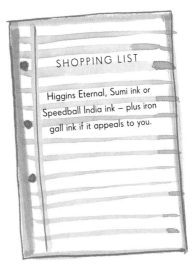

SHOPPING LIST

Higgins Eternal, Sumi ink or Speedball India ink – plus iron gall ink if it appeals to you.

Inky Antics

Although 95 per cent of the people I teach at my workshops now are women, hand lettering has long been an art form dominated by men. Although women who were wealthy enough to be educated wrote personal letters, the field of penmanship as a respected art form was something women had to really work at to be recognized in.

Madame Wei of the Jin Dynasty was a remarkable Chinese calligrapher, not only because of her artistic skill but also because at the time she was learning, in around 300 AD, it was widely accepted that lack of education made a woman more desirable. Madame Wei practised her writing in secret, having watched her father and uncle, who were both calligraphy masters. One day, her uncle discovered her work and felt it had real promise, so decided to allow her to study under his guidance. She went on not only to learn the art, but taught and published on the subject as a respected master.

The first sign of a woman practising calligraphy in Europe appears in print in 1594. Jacquemyne Hondius was a Dutch calligrapher who, through the help of her publisher brother, had her work featured alongside notable calligraphers of the day in a calligraphy anthology.

One of the earliest writing example books to be printed by a woman was Marie Pavie's copybook, published in France in 1600. The book contains two forms of ornate alphabets and script examples, decorated with the hand-drawn borders that were fashionable at the time.

The mother and daughter calligraphers Marie Presot and Esther Inglis made great inroads for women in calligraphy in the 16th and 17th centuries. Marie was a French Huguenot who settled in Edinburgh, Scotland, and set up a school with her husband to teach French. Her calligraphy skills led her to produce two small books for the library of James VI of Scotland – something almost unheard of for a woman at the time. Marie taught her skills to her daughter Esther, who went on to be one of the most famous early women calligraphers. Her work was so widely admired that both Elizabeth I and James I (James VI of Scotland became king of England following Elizabeth's death in 1603) were patrons during her career.

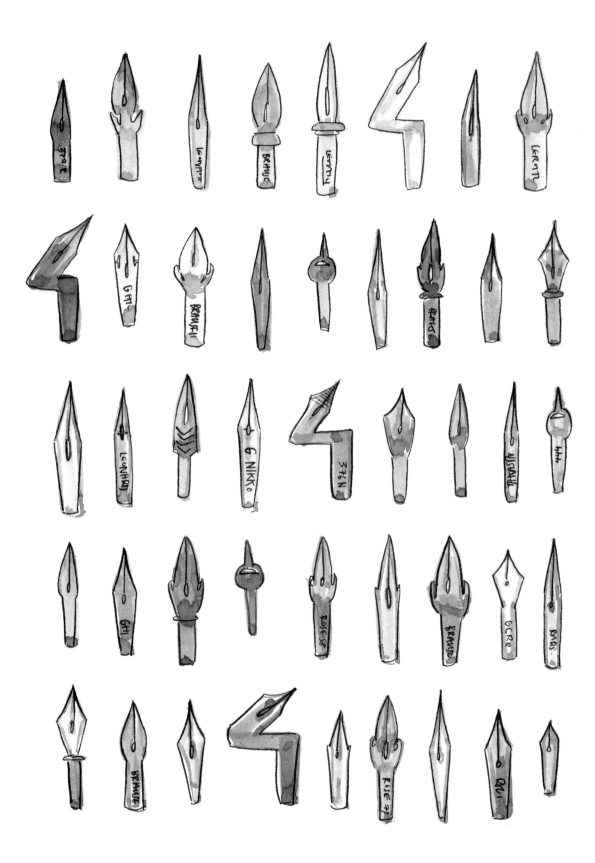

Paper

So I know we've only just met, but I have a confession to make: I smell paper! If I get a new sketchbook or a stack of card for a design commission, I always give it a little sniff and a rub between my fingers. There is something spellbinding about a brand new fresh sheet of paper, ready for a story to emerge on it or a letter to be penned.

You'll find some practice sheets in the alphabet section of this book (page 40–93) that you can use to get started on, but if you catch the lettering bug you'll soon fill these up and will need to invest in some paper and card. Smooth paper is key when you are starting out to allow you to concentrate on the lettering shapes and not worry about your ink bleeding or snagging your pen.

Good paper for practising on is layout paper, HP Bright White Inkjet printer paper, or even a Rhodia notepad. They all have strong but super-smooth surfaces and are less expensive than the types of paper or card you need for a finished project. You will get through piles of paper as you practise, so try to use the whole of a page and don't get disheartened if you make a mistake mid-word. It's really common to want all your work to look beautiful and like a finished work of art, but you are just learning and even the mistakes are things of beauty.

There are hundreds of types of paper out there, which can be confusing when you start out. However, once you have put pen to paper on a few different textures you will start to see which one is right for your projects. Always look for a paper that is at least 80gsm (gsm means 'grams per square metre' and is a measure of the weight of paper). Thicker paper is always better; ink can easily bleed through thin paper, which will tend to rip when the ink adds too much moisture to the surface.

When you think about finished projects, avoid glossy and metallic papers and those with special finishes: the ink will not absorb into the paper but will roll around on the surface. At the other end of the spectrum are watercolour, acrylic or cotton papers that are unfinished. As soon as your nib hits these types of papers, the ink will bleed and the edge of your letters will look fuzzy and frustratingly messy. If you want

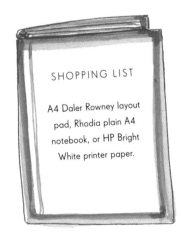

SHOPPING LIST

A4 Daler Rowney layout pad, Rhodia plain A4 notebook, or HP Bright White printer paper.

to use a paper with texture, look for hot-pressed watercolour paper or archival paper. Archival paper is also perfect for a project you want to last for a long time, such as a family tree print in a frame. It is pH-neutral and therefore less likely to yellow over the years.

Papers to avoid when you're starting out include recycled paper, brown Kraft paper, rough watercolour paper, sketchpad/drawing paper, sugar paper and decorative scrapbook paper.

Pencil

A good pencil is really important as part of your toolkit. I plan out lots of my initial drafts and even experiment with new letterforms with my pencil first. Buy a few good-quality HB pencils and a good pencil sharpener for your toolkit. If you have a brand new pencil and are using it for the first time to rule up your work for a project, test it out on a corner of the back of the paper you are using and rub it out to check it comes off easily.

SHOPPING LIST

A couple of good-quality HB pencils. A good pencil sharpener.

Eraser

Invest in a good-quality white eraser – those little pink devils on the top of your pencil just won't cut it. Removing your pencil lines from a large-scale project is the final thing you do, but can also be the kiss of death to your beautiful work. One wrong move and you have snagged your paper or smeared the ink. A good eraser will help prevent this happening and leave no trace on your work.

If you have the time, always leave your work to dry out fully overnight before erasing your planning lines. If you can't wait, test your ink first by putting a clean piece of paper over your work and lightly press to see if any ink transfers to the paper. Always check the last bit of writing you did, not somewhere near the top of the page, so you know the whole script is fully dry.

SHOPPING LIST

Jakar plastic eraser or other good-quality eraser.

Putting pen to paper

It's time to disappear from the outside world into your own inky adventure. I find lettering practice really calming; time seems to fly by without me noticing when I'm totally absorbed in it. Set up your workspace to be comfortable for you. I work on a flat table sitting on the edge of my stool so I can lean slightly on to the table. I know it is tempting to curl up on the sofa in front of the TV and get your ink out on the coffee table, but this is a terrible angle for your work, it will hurt your back, and it won't allow you to fully engage with the process.

Once you are happy with your workspace, give your shoulders a little roll, shake out your hands, and circle your wrists. Your lettering practice will work best if you take your time and try not to rush through the book to the projects at the end. It takes me two or three times longer to write a sentence in a modern lettering style than it does in my normal handwriting, so try to learn to slow down your writing pace.

The scariest moment is ALWAYS just BEFORE YOU start

Putting your nib in your holder

Although nibs are fairly sturdy and can take the pressure you place on them to write, the tines are delicate and can easily bend out of shape if twisted or dropped. Hold the nib by the base, not the tines, so you can insert your nib into the holder without damaging it. The inside of pen holders might look different, but the theory is the same: there will be a tight space between the edge of the holder and the inside into which you insert the nib. The inside of the straight pen holder I have recommended will have a universal insert in, and will look a little like the image shown here.

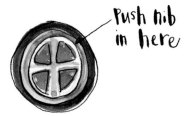

Push nib in here

You need to push the nib into the holder between the outside rim and the four prongs inside. Don't try to push it into the middle of the cross made by the prongs: it won't fit correctly and will bend the prongs the wrong way.

Push your nib in until it feels secure and doesn't wobble around in the holder. Nibs can be tricky to insert and remove at first, but you'll soon get the feel of it. As I use different nibs regularly, I have a few pen holders in my toolkit; I just leave the nibs in the holders after use to avoid having to change them each time I need a new nib.

How to hold your pen

You will have to forget the way you hold a pen to scribble a birthday card or make a shopping list. The biggest stumbling block I see in my workshop participants is re-learning how to hold a pen so that their hand and arm has enough flexibility to create the sweeping motions you need for modern calligraphy letters. We're so used to being on our phones, tablets and laptops that our hands naturally want to curl inwards. Instead, we need to elongate our wrists and relax our hands to create the room to write.

Take hold of your pen as you would a pencil, between your index finger and thumb, resting on your middle finger. Place your fingers about 2cm (¾in) away from the top of the pen holder. Don't hold your pen too close to the nib, as you will end up with ink all over your fingers and work. Relax your grip; your fingers should have a soft bend in them and there should be no tension in your hand and arm.

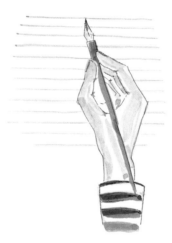

The way in which you use your pointed pen is very different to how you would use a ballpoint or gel pen. You will be moving your whole hand, not the tip of the pen. You need to keep your pen at a constant angle from the paper – about 45 degrees. The tip of the nib should always point in the same direction as you go up, down and sideways. If your pen is too upright, the nib will snag on the paper and the ink will be unable to flow through; if it is too low to the paper, you won't be able to create enough pressure to make thicker downstrokes.

This is the angle of the pen in relation to the paper you are looking for.

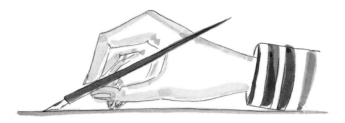

We're looking to make movements using the whole arm, not small, tight movements from just the fingers. Try not to curl your hand inwards towards your chest, as your nib won't be able to release ink properly at this angle. You will need to focus on keeping your nib pointing towards the top of the paper for modern angular alphabets and the top right-hand corner of the paper for the more slanted Copperplate-style letterforms. This may feel strange for a while, as you are retraining your hand to move in a different way than you were taught to write at school. However, you will soon see the benefits of opening up your wrist to help you master the modern lettering style. Once you have mastered the grip for the alphabets in this book, you can play around with the angle of your nib to create your own unique styles of lettering.

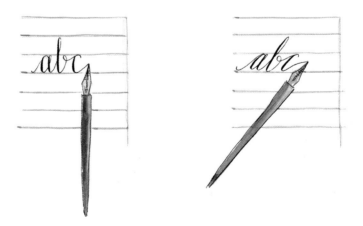

Left-handers

At the time when cursive script began being widely used in schools and for business, being left-handed was not really an option. You would have been told to use your right hand and get on with it. But there's absolutely no reason why lefties can't master using a pointed pen, and I have seen many of my left-handed workshop participants crack it in no time.

UNDERWRITERS

If you are a left-handed underwriter (you write with your hand resting under the words as you write), you simply need to mirror the hand position on page 29 for right-handers. You are looking to create that same relaxed, elongated wrist with your nib pointing towards the top right-hand side of the paper. To give your arm enough room to move, try playing around with the angle of your paper and your sitting position.

OVERWRITERS

If you are an overwriter (you bend your wrist over the top of your writing), you need to follow the techniques in the rest of the book slightly differently. To make the thick lines and thin lines with your nib, you need to reverse the process of a right-hander. All your thick lines will be upstrokes made away from your chest towards your curled hand, and your thin strokes will go down towards the bottom of the paper. For overwriters, smudging can be a problem. You could try placing a rolled-up towel under your elbow so your wrist and hand are not resting fully on the page.

The more practice you do, the more you'll find the right combination of paper angle, pen grip and pressure. You'll be able to create beautiful script that will have exciting unique shapes that a right-hander simply couldn't replicate.

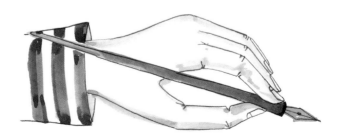

Inking your nib

When you get a new pot of ink, it is tempting to shake it before you open it, but this just creates lots of little bubbles on the surface that you don't want. Carefully open the pot and stir the ink with a paintbrush or the handle of a teaspoon to mix the pigment thoroughly.

Dip your nib carefully into your inkpot just far enough to fully cover the vent hole. This will feel a bit like pot luck at first, but you will soon be able to judge how far to dip and whether you are taking too much or too little ink each time. You can carefully brush the nib against the inside of the jar to remove excess ink, but try not to wipe the nib on the rim of the jar or pot each time – this slowly builds up dried ink that you will then be dragging into your nib.

I always make sure I have a couple of paper towels nearby in case of spillages.

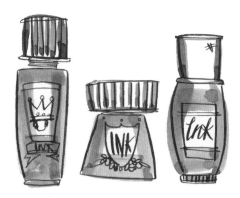

Making your mark

Hurrah! It's time to get some ink on the paper. Over the next few pages we're going to work through a series of practice exercises to enable you to get to grips with your pen. The shapes that you are practising will help you get used to the pressure, angle and flow that you will need to create whole letters.

First, there is one big secret to perfecting your pointed pen practice that I need to let you in on:

**All downstrokes are thick and require pressure;
all upstrokes are thin and need only a light touch.**

This effect is key to creating the modern lettering aesthetic and differentiating it from your regular handwriting. If you can keep this in mind as you begin the following exercises, you are halfway to doing me out of a job!

UPSTROKES – THE THIN LINES

All the lines you make when your pen is travelling up towards the top of the paper should be thin, delicate hairlines. When you are inking your nib correctly, you need to apply barely any pressure to create these lines. These beautiful, delicate movements are one of the unique effects you can get from a pointed pen nib. Even though we will be looking at brush pens and paintbrushes later in the book, I think these lines are one of my favourite things about pointed pen lettering. If you see splatters of ink, or your pen is pushing through the paper on your upstrokes, you are putting too much pressure on the page.

DOWNSTROKES – THE THICK LINES

If you hold your new nib up to a light you can see the two tines and the vent. Gently push the nib flat against your fingertip; you will see the tines separate slightly as you apply pressure. The gap left between the tines is where the ink will flow through to your page. The bigger the gap, the more ink will flow and the thicker the line you create. Mastering how much pressure you need to apply on your nib to create these downstrokes and when to do it in the flow of a letter is key. The exercises that follow will help you gain control of this feeling and get you ready to move on to the full alphabet.

Work through the following exercises, copying out 10–12 of each mark using the practice paper and guidelines until you can achieve a consistent version of that shape.

There are no bad marks you can put on the paper at this stage! Big blobs, scratchy lines, wobbly curves… these are all part of your learning, so free yourself to really experiment without worrying about being too neat. If you are having trouble with one of the shapes, check out the tips on page 106.

Alphabet practice

Now you've got to grips with holding your pen and are a pro at getting the right amount of ink on your nib, let's look at some lettering practice.

In this section, we are going to work through the alphabet letter by letter. It is really important to master the formation of the letters before launching into copying out a full section of Shakespeare's *Henry IV, Part 2*.

Each lettering artist or modern calligrapher has a unique style of lettering. Over years of practice and experimentation, they perfect the lettering shapes that become their signature style. Each time they start a new project, they are able to recreate those letter shapes with ease. If you follow modern calligraphers and lettering artists on blogs or social media, you should be able to recognize your favourite artists' work before you see their name credited. Alongside their signature style, lettering artists will also experiment with different styles to match a specific project brief or a client's preferred aesthetic. This may mean creating some more traditional, angular, childlike or ornate lettering.

To achieve the modern calligraphy aesthetic that is based on the traditional Copperplate letterforms, you need to re-learn the way in which you write some letters.

Let's look at the basic elements that make up a letter and some calligraphy terminology.

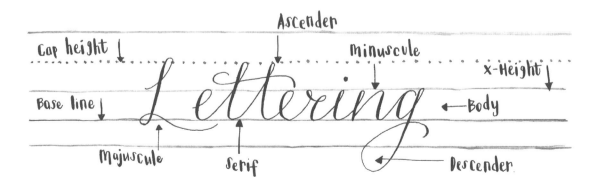

How to use the practice pages

On the following practice pages, you will find a large version of the letter at the top with little arrows drawn around it. This is your basic letterform: the arrows show you where to start the letter and in which order to perform the strokes. Start a letter where you see the star, then follow the arrow, working from left to right. At the bottom of each page is a selection of different letterforms in various styles for you to try when you are confident you have mastered the flow of the basic shape.

Using the guidelines, practise around ten uppercase and ten lowercase versions of the basic letter before experimenting with some of the different styles at the bottom of each page. Take your time with each letter; some you will love the shape of and some will be your nemesis until you find your own version of it. I was not a fan of lowercase or uppercase f/F for a long time, but my brother is called Fred, so rather than phasing him out of my life (I'm quite fond of him) I created a version that I find more natural to write.

You will notice that many of the lowercase versions of the letters begin with an upstroke; this may feel unnecessary now but will be key when you begin to join up your letters to make whole words. If you are having trouble with a letter, try not to let it frustrate you. Move on to the next one and come back to it later. You could also take a piece of your layout paper and place it over the top of the letter page and trace the letterforms until you feel comfortable enough to go it alone.

In your regular handwriting you might stop halfway through a word to dot your 'i' or cross a 't'. I encourage you to wait until you reach the end of a word before you do this, as you will be able to review the shape of the whole word and decide how big to create the cross on the 't' or how high to place a dot on an 'i' or a 'j'. When we move on to flourishes (page 100), you will see how you can use decorative embellishment to add impact to letters using descender and ascender shapes.

Unlike traditional broad nib calligraphy styles that require you to try to match your letter sizes and proportions, with modern lettering you can play around with the angle of your letters, where they sit on your baseline, and the depth and height of your descenders and ascenders.

Guidelines

The lines here are a good basic guide to help you replicate the letter examples; when you become more confident, and as you begin to use lettering on different papers, you will rule up your own bespoke guidelines each time.

Traditional Copperplate and Spencerian guidelines look very different to these printed here, with a slanted line running diagonally across the page to help you keep the constant 55-degree angle required for these scripts. With modern calligraphy, you will play around with this angle, so this is not needed. However, if you decide this is your favourite style of lettering, there are some free downloads available out there in the modern lettering community.

Alright then, you lovely ones, go get lost in your letters!

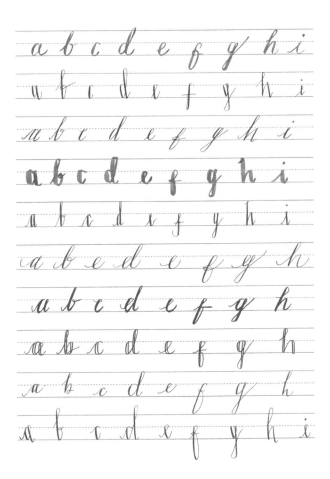

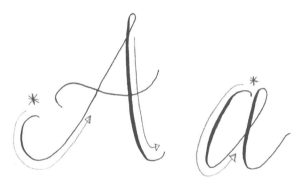

A a

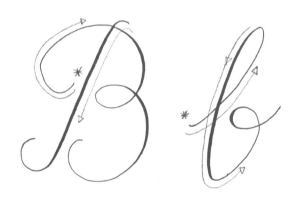

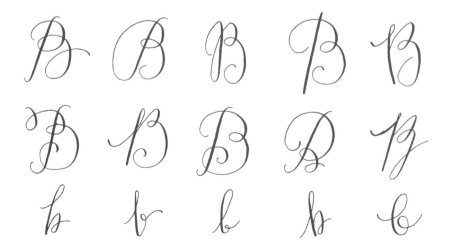

B b

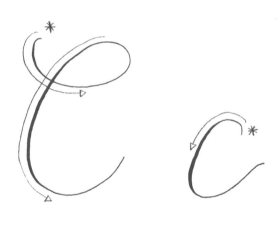

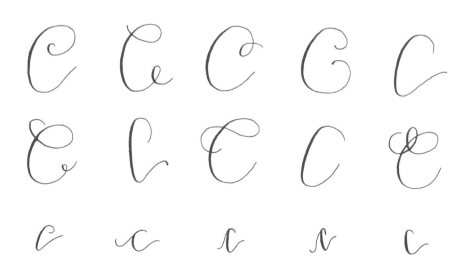

Cc

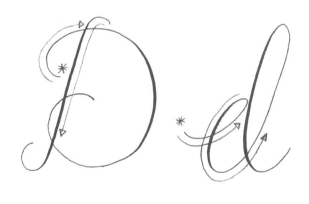

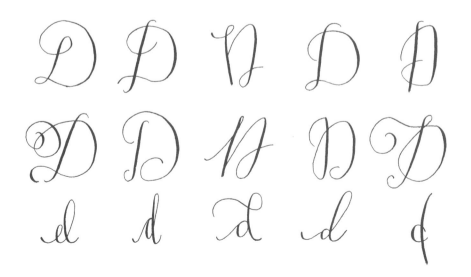

Dd

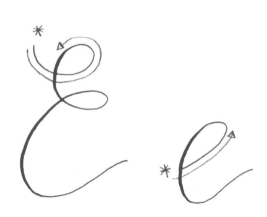

Ee

F f

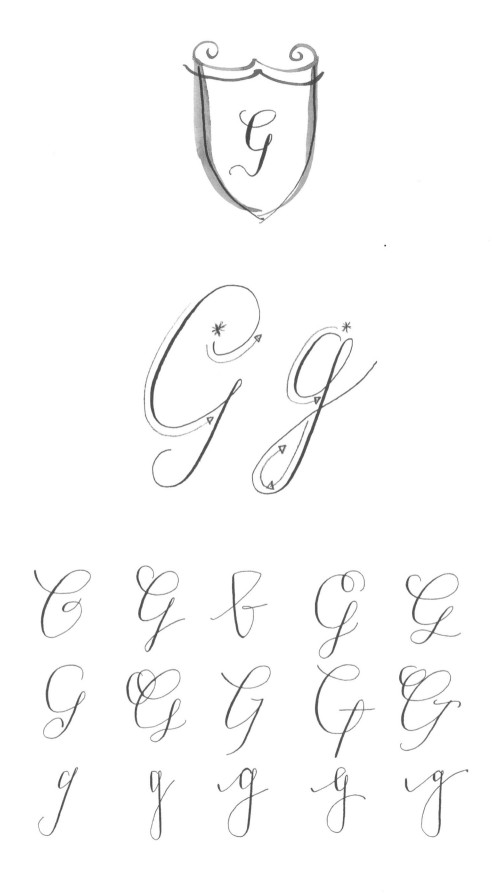

G g

H h

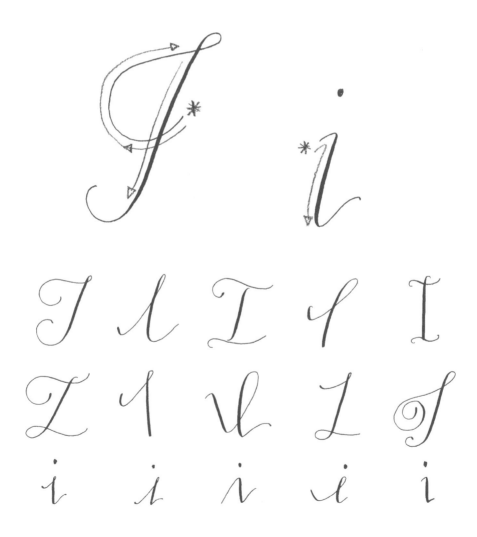

Ii

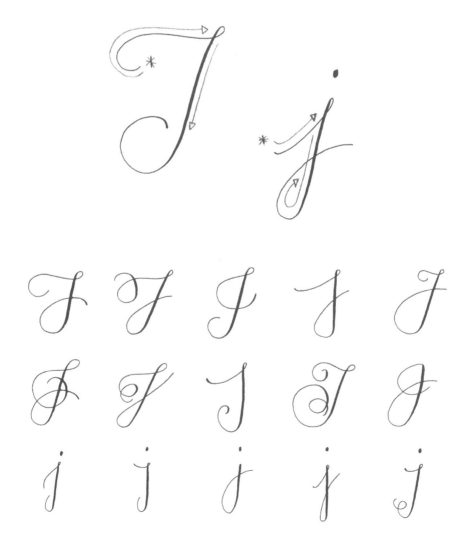

Fj

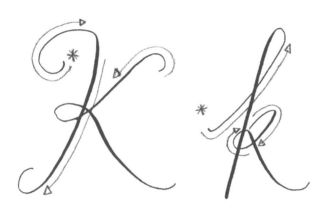

K K R K K K
K K K K K
K k k k k

K k

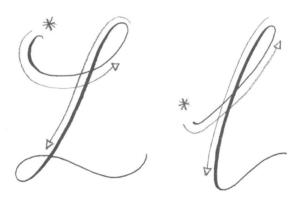

L l

$\mathcal{M}m$

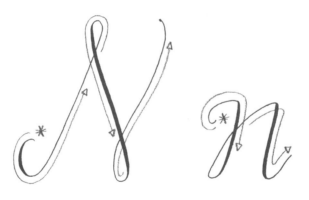

N n

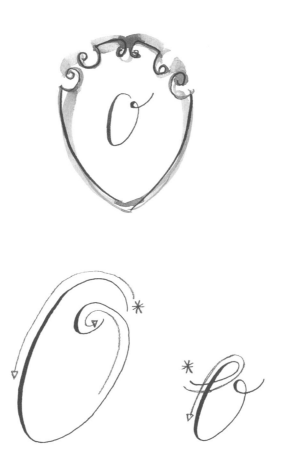

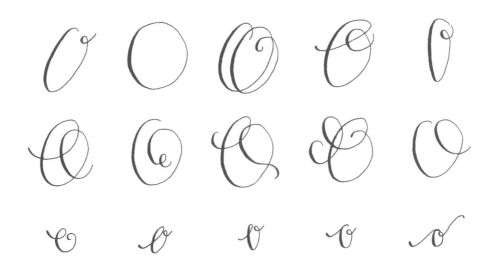

O o

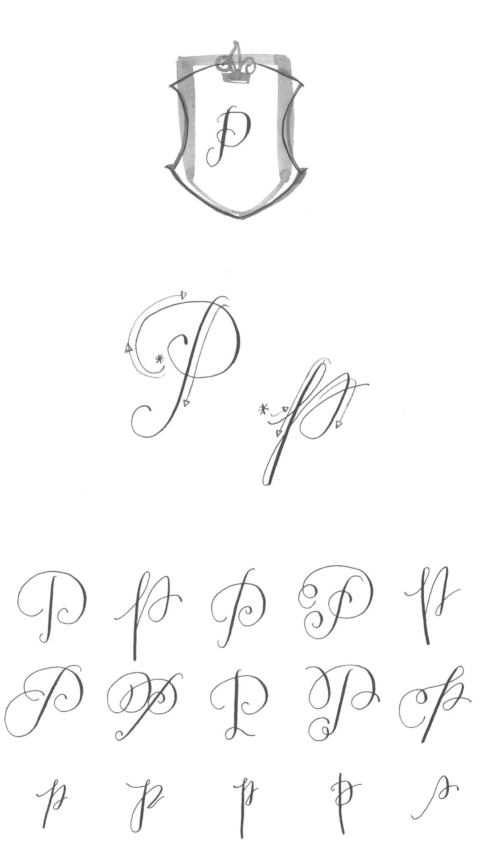

Pp

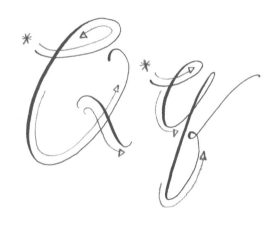

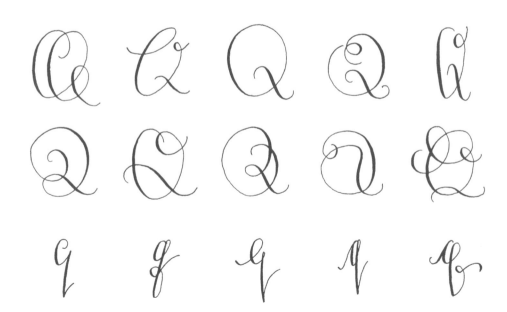

\mathscr{Aq}

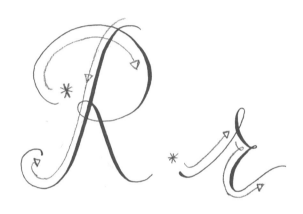

Rr

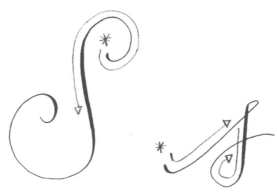

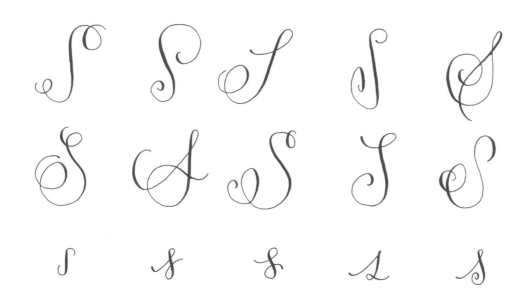

Ss

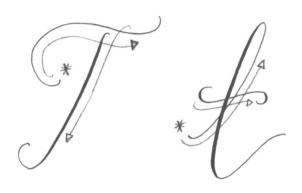

Tt

Ич

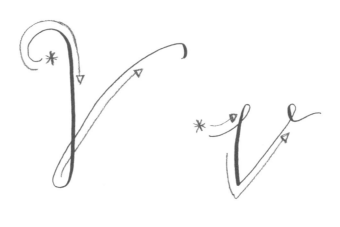

$\mathcal{V}v$

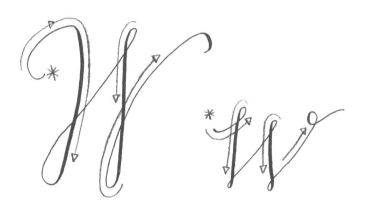

W w

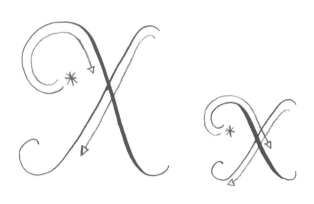

𝒳 𝓍

Yy

Zz

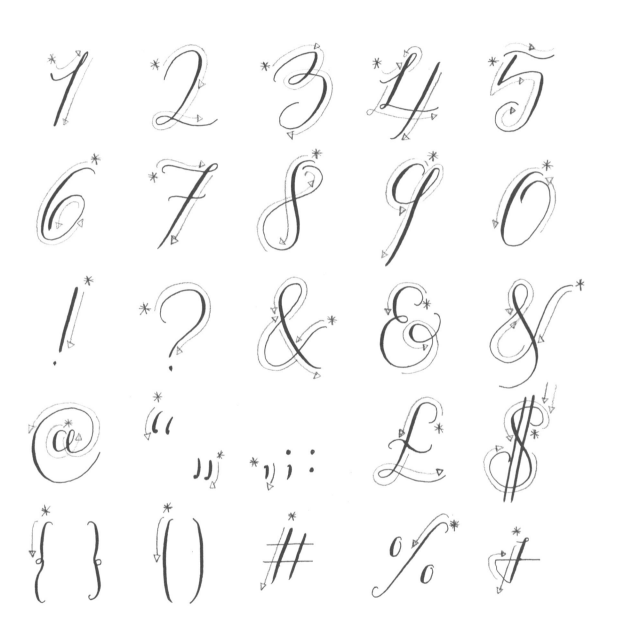

Bring on the words

Once you have filled up your pages with practice letters, you're ready to start putting them together. When penning a quick note in a meeting in your normal handwriting, you just concentrate on the spelling and meaning of the word, but now we also have to think of the word as a picture. Each of your lowercase letters needs to connect to the following letter to create the flow needed for the modern lettering style. You do this by using the connectors (little upstrokes between letters) and the tails (the final upstroke at the end of a letter).

For example, you may normally pen a 'p' like this:

But we need to open up the flow of the letter to allow it to feed from the previous one and join the next like this:

Practice really does make perfect with your letterforms. The more time you dedicate to learning the shapes of the letters, the easier the flow of your work will feel. Soon you won't need to look back at the example alphabet any more; it will just come naturally as a movement. You are slowly retraining your brain to memorize the new letter formations and gain the muscle memory needed to create them.

When bringing letters together to make words, you need to think about the size of your letters in relation to each other and the space you are leaving between them. When you are typing on a computer or phone, each letter you type has been designed to be positioned perfectly to the next, making the text legible and look balanced to the eye. With hand lettering you have to make these judgements by eye each time you are joining letters together.

Initially as you are learning, try to create a consistent distance between letters and make similar-sized letters such as 'e' and 'a', or 'w' and 'm' take up the same amount of space on the line. This will help the overall composition of your writing so that when you look back at it from a distance, it looks balanced. When you start to experiment with your own style you can ignore this rule and see what effect changing the spacing between letters has on your work.

When I ask my workshop participants to start on full words, they all instinctively write their name first. This is a great place to start as you don't have to think about the spelling, just the shape of the letters and the flow. Try the three exercises on the next page. Firstly, for a bit of self-appreciation, write your first name around six times, then your full name, and then add in the words 'is marvellous'. Then you can experiment by joining the British nobility for the day and practise giving yourself a grand title. They have a good selection of descenders and ascenders to get the hang of. And finally, try your hand at a little bit of Cockney rhyming slang.

Cockney rhyming slang originated in the early 19th century in East London. It was used as a way for market stall traders to have secret conversations between themselves without customers knowing what they were planning. The rhymes were based on well-known locations, events or personalities at the time of creation. Traditional rhymes created in the 1850s like 'Hampstead Heath' meaning 'teeth' are still used, but the language is constantly added to with modern-day references such as 'he was wearing his Barack Obamas' – meaning pyjamas.

Elvis

Elvis Presley

Elvis Presley is marvellous

The Marquess of Tweedale

The Earl of Coventry

The Duke of Lancaster

Baroness Darcy

Apples and pears – stairs

Trouble and strife – wife

Nice cup of rosie lee – tea

Whistle and flute – suit

Making it your own

Hurrah, you've tamed your pen and ink and are well on your way to becoming a modern lettering master. But before I leave you to your own inky antics, let me tell you about some other techniques you can integrate with modern calligraphy and some key modern lettering skills to add to your ever-increasing repertoire.

Now you have been practising the letters in the alphabet section of the book, it's time for you to really get your ink on and invent your own lettering styles. You may have already started to find ways of drawing a letter that is unlike any of the examples given so far – wonderful! When I first started out I went through sketchbook after sketchbook trying out different styles and cutting out the one 'h' or 'P' of the 60 I'd drawn that I liked. I slowly pieced together some master sheets with a full alphabet of my favourite letters to create my own letter guides.

You may be happy simply using some of the alphabets within this book, but if you would like to take your hand lettering to the next level, here are some ideas to try to spice up your script a little. Firstly, try playing with the angles of the letters so each one has a slightly different slant. Then move on to experiment with the proportions of the spaces between the letters to emphasize sections of the words. Next, change the height of your descenders and ascenders to create a more dramatic effect, and finally, allow letters to sit above and below the guidelines, giving the writing a quirky, jumpy feeling.

As you practise, circle versions you like or cut them out so you can build your own master sheets of your favourite examples. That way you don't have to keep every single sheet of practice paper, but you can record your development to use as reference in the future.

put pen to paper

put pen to paper

put pen to paper

put pen to paper

flourishing

Flourishing is like adding great accessories to an already fabulous outfit. You just can't go wrong! I've heard flourishing called 'swirly bits', 'loopies', 'fancy lines' and 'the fiddly bits' in my workshops; whatever you decide to call them, they are embellishments added to a letter or around a letter to decorate the script. You can add in flourishes whenever you want to in your work – it is entirely your choice. This is what makes creating modern calligraphy by hand instead of using a pre-designed digital font so exciting!

The technique for flourishing follows the same basic rules as the letters: downstrokes are thick and upstrokes are thin. Be sure to only cross a thin line with a thick line, not thick/thick or thin/thin. Flourishing needs to balance across your text so don't add it all to one side, bottom or top. I think the most successful flourishes give the words a frame to sit within but don't overpower them. You should avoid sharp corners or angular shapes, and try to end your flourish by returning the line in towards the starting point, not away from it.

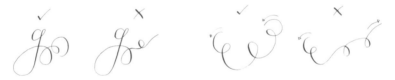

When you start using flourishing it can be easy to get carried away and lose the clarity of the actual writing. It should only enhance a composition, not overpower it.

I like to add flourishing to my script in four main places:

The beginning letter of a sentence
The tail of the final letter on the page
On descenders like 'j', 'g' or 'q'
On ascenders like 't', 'h' or 'b'

When you are drawing flourishes, your arm should move freely and smoothly. I seem to end up making large dramatic movements like a tortured artist when I'm doing mine. I dread to think what my facial expression is like when I'm doing them!

To show you how different a word can look when you add flourishes in different places, here's the same word with four different examples of embellishment. Now you're in the flow, try copying the examples below:

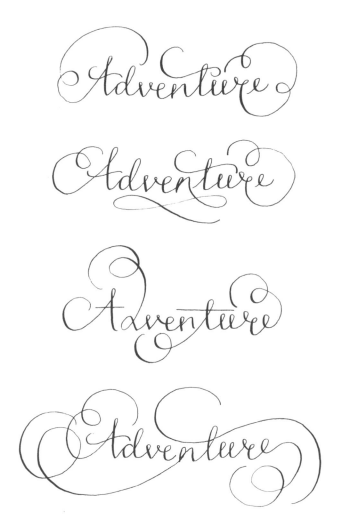

Use the following few pages to try out some flourishing techniques. If flourishing is something that appeals to you, try using the Brause Rose or Leonardt Principal nib to achieve extra-fine lines.

To warm up your hand for some flourishes, try some of these
exercises first.

llll

of

Ull

One last thing you could consider when thinking about the layout of your lettering is adding a motif. Small illustrative elements can add character to a quote or a piece of text. But use them sparingly, and always leave enough room to ensure your lettering is still legible. Here are a few of my favourites for you to add in to your own compositions.

SCROLLS

ARROWS

STARS

FEATHERS

FLOWERS

Help!
What am I doing wrong?

The following sections should help you troubleshoot.

THE INK IS BLEEDING ON MY PAPER

If you are working on the practice pages of this book and your ink is bleeding, your ink may be too thin. Decant around 15ml (1tbsp) of your ink into a small pot and leave it open overnight. This should thicken the ink up a little and stop it running through your nib too quickly. If you are working on your own paper, you might have chosen a paper stock that is too porous and therefore can't hold the ink well. Look at the paper section on page 24 and try to hunt down some of the recommended paper for practising on.

THERE DOESN'T SEEM TO BE ANY INK COMING OUT OF MY NIB

You may not have dipped your nib in far enough. If you have dipped your pen in over the vent hole there should be plenty of ink to write a line of practice shapes. Try dipping it in further to see if this helps. If this doesn't work, you may not have cleaned the nib properly, so give it another quick scrub with warm soapy water.

BIG BLOBS OF INK COME OUT WHEN I FIRST PUT MY NIB ON THE PAPER

This could be down to you dipping your pen too far into the inkpot, which will load your nib with too much ink. Using a paper towel, remove the excess ink and try dipping again, but not letting the nib go too far into the ink.

Another reason the ink is creating blobs could be because not all the manufacturer's oils were removed fully when you cleaned the nib. Remove the nib from the holder and go back to page 17 to follow the cleaning process once more.

MY PEN SNAGS ON THE PAPER WHEN I MAKE UPSTROKES

Can you hear a scratchy noise on the paper when you draw your upstrokes? If so, your nib is probably at the wrong angle. The nib can only release ink on an upstroke if the vent on the nib is facing up. If it is rolling too far to one side or another the tines will rub against each other and the ink will not be able to flow through them. Try to correct the angle of your nib and reduce the amount of pressure you put on the nib on an upstroke. If you have the right amount of ink on your nib, the pen will do the work for you; you barely need to press down at all to get a beautiful hairline upstroke.

SOMETHING IS STUCK IN MY NIB

This could be a fragment of paper, fibre from the cloth you cleaned your nib with, or dry ink. Hold the nib up to a light – you can usually see clearly what is stuck in the nib. Take a minute to clean the nib properly and dry it carefully before re-inking your nib.

I'M MAKING INK MARKS WITH MY HAND ON THE PAPER

If you are already covered in ink you are probably holding the pen too closely to the nib. Try to make sure your fingers are at least 2cm (¾in) away from the top of the pen holder. If you are finding that you are picking up ink from the page as you move your hand across, you can place a piece of clean blank paper under your hand where it is touching your work. Keep moving the paper down as you write so it remains under your writing hand but clear of your writing.

THERE'S NO DIFFERENCE BETWEEN MY UPSTROKES AND DOWNSTROKES

Try not to get frustrated about this at this early stage – it will come with practice. Your upstrokes only need a very fine touch against the paper, but be bold and brave on your downstrokes. Your nib is made to take a little pressure; practise drawing some simple thick downstrokes, but push down slightly more than you have been.

MY HAND IS HURTING/I HAVE CRAMP

This is really common; it is due to you not writing by hand often any more and possibly having too tight a grip on your pen. Relax your hand and make sure you take regular breaks, stretching out your fingers. This is an excellent opportunity to pause for a biscuit!

I CAN'T MAKE THE LETTER

Not all letters will come easy. Remember that some of their formations are inspired by Copperplate and Spencerian scripts that people went to dedicated colleges to learn and took years to master. Don't become disheartened: you are learning a brand new craft and you wouldn't expect to be able to knit a full jumper the first few times you pick up knitting needles.

Grab a spare piece of practice paper and your pencil. Copy or trace the letter you are having trouble with in pencil, and repeat the shape 12–15 times until you get the flow of the letter formation. Then go back to your pen to see if this has helped. If you are still having trouble, try using the pencil to see how you normally write that letter, then find a way of using connectors to make your letter flow with others in a word. I'd much rather you found a way of adapting a letter than try to avoid it or get frustrated.

I RUN OUT OF INK AFTER A FEW LETTERS

You will get better and better at judging how much ink you need on your nib the more you use it. If you are running out of ink quite quickly you might not be dipping far enough to cover the vent. Try dipping a little further and see if this helps. It is also possible you are pressing quite hard on your nib and creating heavy downstrokes that use a lot more ink. Try easing up on the pressure a little to make your ink last longer between each dip.

When you are a little more practised, you could invest in a reservoir to fit over your nib. This is a small metal attachment that will allow you to collect more ink on each dip. I don't advise using one when you are starting out, as you need to get used to the pressure and ink flow at first. However, if you fall in love with lettering and want to further your practice this might be worth considering.

I CAN MASTER THE LOWERCASE BUT I'M HAVING TROUBLE WITH THE UPPERCASE LETTERS

The uppercase letters are pretty fancy, aren't they! Take your time with these; if needed, go back through and practise a run of them again to help memorize the movements. These letters are designed to create impact at the beginning of a sentence: if you are using them in long pieces of copy, try simplifying them slightly so they don't interrupt the flow of your text too much. The key to uppercase letters is practice, practice, practice (you're beginning to see a theme here, right?). The way in which you write these letters may be very different to capital letters in your handwriting, so it will take time to get used to the order in which you need to make each stroke. As with your lowercase letters, practising the format with a pencil a few times can help you to figure out how to position your nib for uppercase letters.

MY LETTERS DON'T SIT PROPERLY ON THE GUIDELINES

I often have participants in my workshops who find it hard to keep their letters on the guidelines. When you are a beginner, concentrating on getting the flow of the letter correct, you can start in the right place but end up somewhere completely random. The clue is in the name: the guidelines are simply a guide – don't let them discourage you. When you have gained good control over your nib and ink you will find it

much easier to hit that guideline each time. But also try to explore the little quirks you are making in your lettering. As I mentioned in my introduction, being able to break out of the guidelines and embed your own personality in your hand lettering is one reason why I love the modern calligraphy style.

I'VE CLEANED MY NIB BUT THE INK STILL ISN'T FLOWING THROUGH IT PROPERLY

Is it possible you have dropped your nib or bent it somehow? Hold it up to the light: if the tines are not positioned together in a perfect line then your nib has been damaged and won't be able to release the ink the way it needs to. You will need to invest in a new nib and make sure you store and install it correctly.

Could it be your ink? If you have left your ink open for several days it may have thickened slightly; try adding a few drops of water to thin it out. Or perhaps you are trying some Indian ink that has a much thicker consistency than the Higgins Eternal. This will take a little more practice to get used to; you may need to experiment with using pressure differently or experimenting with different types of paper to see if this helps the ink flow more easily.

Sometimes nibs come from the manufacturers with slight imperfections. They make thousands each day, so every once in a while one will be misaligned or have a fault. If you have tried cleaning the nib thoroughly and the ink still won't flow, it may be due to a factory fault.

HOW OFTEN SHOULD I PRACTISE?

Unlike learning the violin, you won't annoy anyone with your modern calligraphy practice as you are learning, so try to squeeze in as much practice as you can in the first few months. When I have been away on holiday or I have a new client that wants a unique style creating, I still have to go back to my layout paper and run through my letterforms to get my head and hand working together again. The more time you can spend on practising, the quicker you can leave my alphabet examples behind and start writing from memory.

This is not the kind of hobby you can get out on the train easily, so you do need to put aside dedicated time at home at a desk to practise properly. It can be pretty hard going when you are just repeating letter

after letter, so mix it up by giving yourself some creative challenges. Copy out the lyrics to your favourite song, write out your shopping list in modern calligraphy, or take a small passage from a book you are reading.

If you are becoming disheartened or frustrated, seek inspiration from others. Get online and watch some tutorials or look at other people's alphabets to keep you motivated. The modern calligraphy community is supportive and collaborative, so explore other people's learning journeys to help inspire your own.

MY WRITING IS SHAKY; I CAN'T ACHIEVE CRISP LINES

This is a really common complaint in my workshops. Don't panic – you are using different muscles in your hand than you would if you were just using a biro, so your control might be hit and miss at first. Relax your hand and grip the pen holder at least 2cm (¾in) up from the nib base. The movements you're making need to come from your whole arm, not just your fingers, so try to create a smooth, gentle motion as you write.

Try playing around with the angle of your paper to make it work better for you, and make sure you are sitting somewhere where your wrists can be supported properly. With practice, your stamina and control will improve and you will start to see your lines becoming stronger and more accurate.

When you have used up all the pages in this workbook and have moved on to layout paper, invest in an A4-sized clipboard to keep your page secure when writing. Or use Washi tape to gently secure your practice paper to the table. This will help prevent your paper from moving around as you are getting to grips with your pen and help stop your letters looking shaky.

Cherish your imperfections

In our modern digital world, mistakes and imperfections on a page are easily rectified. We are used to being able to crop and put a filter on a photo, hit the delete button to change what we have just written, or manipulate drawings in programs such as Photoshop. One big learning curve that comes with practising modern lettering is to release the fear of making mistakes and embrace your imperfections.

I can't tell you the number of times I have reached the bottom of a page of lettering and realized that I really don't like the shape of a letter in the fourth line. Or I have just been coming to the end of a wedding invitation design and smudged a letter accidently with my sleeve. When this happens, there is no delete button. You either have to embrace the mistake and think of a way of amending it – or start again.

This can be frustrating, but when it happens to me I try to remember that the most exciting part of lettering is that it is created by hand, not by a computer; everything you create, even practice sheets, are little works of art that cannot be duplicated.

Often mistakes can happen when you are rushing your work, so try to pace yourself. Put some music or a podcast on to help you relax. Your ability to spell correctly may also fail you when practising modern lettering because you are concentrating so much on the shape of the letters. There have been many times when I've paused to look at my work mid-flow and realized I've missed an 'r' out of 'Christmas' or added an extra 'd' to 'wedding'! It helps to have a simple copy of the text you are writing beside you so you can quickly refer to it.

An important thing to remember is that your letters don't have to look exactly like my letters. In fact, I would be thrilled if they looked completely different, as this would mean that you have confidently found your own style! (Makes sobbing noise into a hanky like a parent watching their child go off to university…)

THE

biggest

Mistake YOU

could EVER make

IS

being

TOO afraid TO make

one

INKY ANTICS

When I started teaching workshops, I didn't realize I would be asked so many feather-related questions:

- Is a quill really made from a feather?
- Can you use any feather, or is there a particular type you need to make a quill?
- Did Shakespeare use a feather to write with?
- Can you put a cartridge in a quill?

And, one of my personal favourites:

- Can left-handed people only use feathers from left-handed birds? (I didn't know where to start or end with that one!)

So, what is a quill and how is it different from the pointed pen we are learning to use?

A quill pen is made from a discarded feather from the wing of a large bird. Quills were the main writing tool in Europe and the Western world from around the 7th century through to the 19th century, replacing the reed pen. Most quills were made from goose feathers. Although you might imagine them to look like a full plush feather, they were commonly stripped apart from a small section at the top of the feather to make them easier to hold. Quills lasted a long time, so their popularity grew quickly. They were used to write world-famous documents such as the Declaration of Independence, and Shakespeare did indeed use a quill to pen his plays and poems.

Preparing a feather to be a quill is called 'dressing'. This was originally done using a special knife, which came to be known as a penknife. The feather would work in a similar way that your Nikko G nib does, with a slit to separate and allow the ink through, and the hollow shaft of the feather acting as a reservoir instead of a vent hole.

I'm quite glad that the mass production of steel nibs began in the 1820s – the only birds I see regularly around my studio in London are scrappy-looking pigeons, and I fear their feathers wouldn't lend themselves to producing luscious lettering!

Adventures in different media

When I'm in an art materials shop, I just can't be trusted to come out with what I went in for. My shopping bag always seems to find a few extra paints, a sketchbook with paper I haven't tried yet, or a brush pen in a new colour. You can now start to build up your tool kit with coloured card, writing tools and paints, experimenting with the variety of different effects these will give you. Before we move on to some lettering project ideas, let's have a look at the materials you could begin to collect and how to get to grips with them.

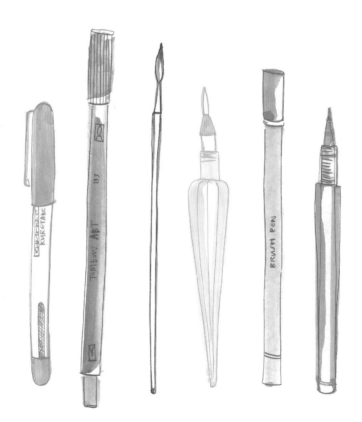

Using paintbrushes

I love using brushes in my work and have recently been creating a
new children's alphabet using a small brush and ink with little inky
beasties. Try experimenting with a paintbrush to see how you can create
the same letterforms by using either a light or a heavy stroke. You will
need a round-head paintbrush and your choice of ink, watercolour,
acrylic or gouache paint.

As with the brush pens, hold your paintbrush at around an
80-degree angle to allow you to create both delicate upstrokes and
thicker downstrokes. The bristles of a brush will release a lot more ink
or paint than your pointed pen can, so your writing will appear slightly
thicker than before. However, with practice you can still create very thin
upstrokes and thick downstrokes with a single brush.

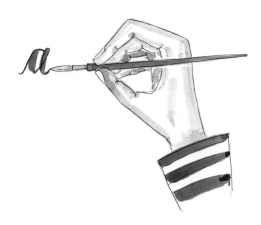

ROUND-HEAD BRUSHES

To produce modern calligraphy letterforms with a paintbrush you need
a round-head brush, not a flat-head one. The round-head bristles will
allow you to create the sweeping motions you have learnt with your
pointed pen, but will not have to be held at a constant angle to create
thin and thick strokes as a flat-head brush would. I use Winsor &
Newton Cotman Watercolour Round Series brushes in a range of sizes;
size 3 is a good one to start with. Always clean your brushes well after
each use to make them last. Never leave them to stand in your water pot,
as this will ruin the end of the bristles.

HENRI MATISSE

WATER BRUSHES

Water brushes have become popular over the last few years with the rise of the Brush Script style. Instead of a hard handle, a water brush has a soft plastic barrel that can be filled with water. As you softly press the barrel of the brush, a little water is released into the bristles of the brush. This means that, instead of dipping your brush into a water pot, you can simply press the brush for water to mix your paint. Because you can add water throughout the word without removing your brush to have to dip, you can create delicate colour-fade effects as the original paint is slowly watered down while you work.

I often use a water brush in a slightly different way by filling it with ink and using it directly on to the paper. This can make some really interesting abstract marks and textures in your lettering and allows you to create thick, inky letters. If you use ink in one of these brushes, clean the bristles thoroughly to ensure that all the ink is completely gone before you go back to using it just for water with paint.

SHOPPING LIST

Pentel Aquawash brush, Kuretake Phys water brush, Winsor & Newton Cotman Watercolour Round Series brush, size 3.

Have No fear
of
Perfection
You'll never reach
— it —
Salvador Dali

You can make
anything by writing
C. S. Lewis

Using brush pens

Although there is nothing quite like the delicate effect you can create with a pointed pen and ink, there is a great range of pens available that can be used to emulate the effect of a pointed pen and create new looks for your lettering.

These pens work using the same principle as a pointed pen – the downstrokes are thick and the upstrokes are thin – but with these pens you control the effect by using the pen at a slightly different angle to your pointed pen. For the brush to spread and allow you to create a deep thick line, you need it to be at around an 80-degree angle, so the brush nib is lying almost horizontally in line with the top of the paper.

Some pens, such as the Tombow ABT Dual brush pen, come with two ends: one fine tip and one flexible tip that looks more like a regular brush. These two tips allow you to create a fake calligraphy effect by writing all your letters in the fine tip and then adding in a thick downstroke with the brush tip.

First write your word in a single thin stroke using the fine tip of the pen.

thank you

Then go back over your word with the brush end of the pen, adding a thick stroke to all of the sections of the word that feature a downstroke and leaving the upstrokes untouched.

thank you

If you are struggling to work out which one is which, imagine you're using your pointed pen as you work through the word; only use the thick brush pen end when you would have been applying pressure to your nib on a downward movement.

You can also just use the brush pen nib to write the whole word in one and still create definition between the thin upstroke and the thick downstroke. To do this, simply press more lightly on an upstroke and retain the angle of your pen at 80 degrees all the way through the word.

You can use the same type of paper as with your pointed pen; regular printer paper will be more receptive to this type of pen than the Higgins Eternal ink you have been using with your pointed pen.

Brush pens come in a large range of colours; some makes are even blendable, so you can start to experiment with colour in your lettering. As with your pointed pen, if you get stuck on the letter formations, try picking up a pencil and practising the flow a couple of times first before going back to your pen again. Using the same alphabets as before, try experimenting with a brush pen to see what your letters look like in this medium. You could even try a metallic brush pen on darker-coloured paper, such as the gold or silver Kuretake Zig Fudebiyori Metallic brush pens.

SHOPPING LIST

Pentel Touch Brush Sign pens,
Tombow ABT Dual brush pen,
Kuretake Fude brush pens,
gold or silver Kuretake
Zig Fudebiyori Metallic
brush pens.

INKY ANTICS

LETTER-WRITING ETIQUETTE

Letter-writing etiquette was once extremely important as an indication of social status. A well-written letter was the sign of good education, wealth and fine manners. In Victorian England, women would be expected to write letters to their peers to share news of the family's success, and keep up with letters of thanks, congratulations and condolence. While the men of the house would be responsible for all business letters, it was left to the women to use their letter-writing skills as a kind of PR campaign for the family.

The next time you are using your new lettering skills to send a bit of personal post, think about these Victorian letter-writing etiquette tips:

- Men can use only plain paper with no decoration, but women may use ribbon, floral papers and even add a light spray of perfume to the paper before writing.
- Women must write with passion and unbridled emotion, but also be careful not to share too much!
- Use black or dark brown iron gall ink for all personal correspondence.
- Should you run out of paper for a personal letter to a familiar friend, you should turn your page by 90 degrees and write across the page in the new direction over your previous writing.
- When writing a love letter to a possible suitor, use only one gentle compliment per letter. Any more than that could appear vulgar.
- No ink stains or blots should be allowed on your letters. If you have made a mistake, begin the letter again.
- For a letter of mourning, use appropriate stationery with a black border around the edge of the paper. The closer the relative was to you and the greater the loss, the larger the black border should be.
- Finally, never send a letter that uses only half a sheet of paper. This looks cheap and conveys the message that you have nothing of interest to say and do not respect the recipient enough to take the time to pen a whole letter.

Working with coloured paper and inks

There is only so long you can write with black ink on white paper before you feel the pull of coloured ink and card. There is a whole world of colour combinations and ink effects to explore to give your lettering the fancy treatment it now deserves.

When working with coloured inks and paints, keep a little jar of water near your workspace to use for mixing, but also to dip the very tip of your nib into should your ink stop flowing correctly. For most coloured inks you can continue to dip your nib into them as you have been doing. If you are only mixing a small amount of colour that is not enough to dip into, use a small paintbrush to apply the colour to the back of your nib.

COLOURED INKS

There are several makes of ready-made coloured inks available, all with their own unique tones and consistencies. I love working in colour, but find many ready-made inks thin and watery, so I prefer to use a gouache paint mix (more on that in a moment). If I am using coloured inks, I buy Winsor & Newton calligraphy inks; they come in a range of colours and are one of the thickest I have found that give a strong, crisp finish.

You might find that coloured inks seem to run through your nib quicker than most black inks, due to their high water content. Practise on a scrap piece of the paper you have chosen to use first to get used to the consistency before starting on your project.

DARK-COLOURED PAPER OR CARD

Penning a piece of beautiful script using light-coloured or metallic ink on dark-coloured card can create stunning effects. You can create beautiful colour combinations, such as dark navy paper with copper ink, or dove-grey card with neon pink lettering. However, writing on coloured card comes with its own set of problems, as you can no longer use a set of guidelines underneath or get help from a light box.

If you feel confident enough to write freehand on coloured card, you can simply ink up your nib or brush and get cracking, but if you feel that you need guidelines to help, invest in a soapstone pencil. Soapstone is easy to see on dark-coloured card and will rub away when you have finished. As with all your card and paper choices for lettering projects, be careful to match your card choice to your ink and nib.

GOUACHE

I adore the thick chalky effect that working with gouache gives and often prefer to use this to the pre-mixed calligraphy inks. The vibrancy of the colours when dry is fantastic and although it takes a little while to get the hang of mixing it correctly, the results are well worth it.

If you'd like to have a go at using gouache, mixing a little batch of it up is easy and one small tube of gouache will go a very long way. Gouache comes as a thick paste that feels almost dry to the touch. It needs to be mixed with water to be used but because of the way in which its pigment is made, it will remain opaque even after it is mixed. The quality of the gouache you buy will really affect the clarity of the finished lettering so this is one item it is definitely better to splash out on.

Find a small airtight container or jam jar and squeeze a small amount of your chosen coloured gouache into the pot. Add 5ml (1tsp) of water and begin to mix, slowly adding in a little more water until the consistency is that of whole milk. Be careful not to add too much water at once, as you only need a small amount and if the paint is mixed too thinly it will not sit properly on the paper. Distilled water is best for this process, as it will enable you to keep your paint in an airtight jar for longer without spoiling. But tap water is fine if you are just using it for one project.

Gouache does tend to smudge even when dry on your projects, so if you are using it for something like an invitation, you'll need to add a few drops of gum arabic to the mix. This is a binding agent so will help keep the structure of the paint on your final project. It comes in powder or liquid form; I find the liquid form easier to use for this process. Different brands of gouache will require different amounts of gum arabic and water ratios, but as a guide, for the Winsor & Newton tubes I use in a 15ml pot I use around 50 per cent gouache, 40 per cent distilled water and 10 per cent gum arabic (roughly six drops). If your mixed ink isn't flowing very well, add in a few more drops of water to the mix until you are happy with the consistency for the nib you are using.

You can mix colours together to create the perfect tone for you, but to lighten gouache you must add white to the mixture, as adding more water will only dilute the mixture, not make the colour lighter. You can use white gouache or Dr. Ph. Martin's Bleed Proof White to lighten the shade. Gouache will dry slightly darker than the colour of the wet mixture, so bear that in mind when deciding on your final colours.

WATERCOLOUR PAINT

In the same way that gouache can be mixed for a pointed pen, so can watercolour paint. Watercolours have a beautiful thin consistency that can create delicate but luxurious lettering, perfect for wedding stationery, religious texts or quotes from your favourite childhood books. It comes in both palettes and tubes. Both are suitable for our purposes; the only real difference is the quantity of paint you can mix up with a tube versus a palette. If you fall in love with watercolours, invest in tubes of paint, but a small palette of basic watercolours will be perfect to get you started.

You mix watercolour in much the same way as you do for gouache, only the paint will be slightly thinner. If you are using a palette to mix your colours, you will need to use a brush to apply the paint to the back of your nib. If you are using a tube, you can make up a pot of the paint and dip into it as you would with black ink.

One of the things I love about watercolour is that you obtain slightly different colour tones throughout the letters in your words because the ink continues to mix as it works through the nib. I think this gives the lettering an enchanting feel and makes each finished piece unique, even if you are making 100 copies of the same 'Save the Date' card.

Try adding a little drop of a different colour to your nib as you work and watch as the colours bleed into each other, creating a beautiful multi-coloured effect. If the paint begins to thicken or dry on your nib, dip the very tip of the nib into your pot of water to help it run smoothly again. As well as using watercolours for your lettering, you can also paint stunning backdrops for your work by creating light washes of colour that, once left to dry thoroughly, can be written over in a contrasting coloured ink.

METALLIC INKS

There are some great metallic ink options available; my favourites by far are the Finetec palettes. They come alive with just a little water brushed over with a paintbrush; you can then paint the back of your nib and get cracking. These inks come in a range of gold or pearl metallic colours that sit beautifully on the paper and shimmer in the light.

Mixing the ink and getting it to flow through your nib correctly takes some getting used to. If you find that the ink is not moving through the nib smoothly, you may need to add a little more water to the mix. If the colour on the paper looks weak and the paper is showing through, you may have added too much water. Leave the palette to dry out a little until the paint has thickened again.

WHITE INK

If I have time, I always opt to use gouache paint for my white lettering, but there are some ready-mixed white inks that sit well on many paper surfaces. Dr. Ph. Martin's Bleed Proof White is a great product and works well with a Nikko G or Brause Rose nib after a bit of practice. It will feel much thicker than your other coloured inks and may clog on your nib. If this happens, stir a few drops of water through the ink to thin it out.

When you first start to use a new pot of the ink you might find it is too watery. Leave the top off the ink for an hour to dry it out a little, mix the ink thoroughly, and try again on a clean nib. If it is still too watery, repeat the process until you are happy with the consistency. If you can't get hold of Dr. Ph. Martin's Bleed Proof White ink, try the Winsor & Newton white calligraphy ink.

In my experience, white ink seems to dry quickly once opened, so keep the lid of your ink tightly shut when not in use. You may also find that if you do not use the ink very often it separates out and will need a good mix to bring it back into a useable state.

SHOPPING LIST

Winsor & Newton coloured inks and gouache, Finetec ink metallic palettes, watercolours in either tubes or palettes, soapstone pencil, Dr. Ph. Martin's Bleed Proof White ink, a small paintbrush for mixing, and small mixing pots for your ink with screw-top lids.

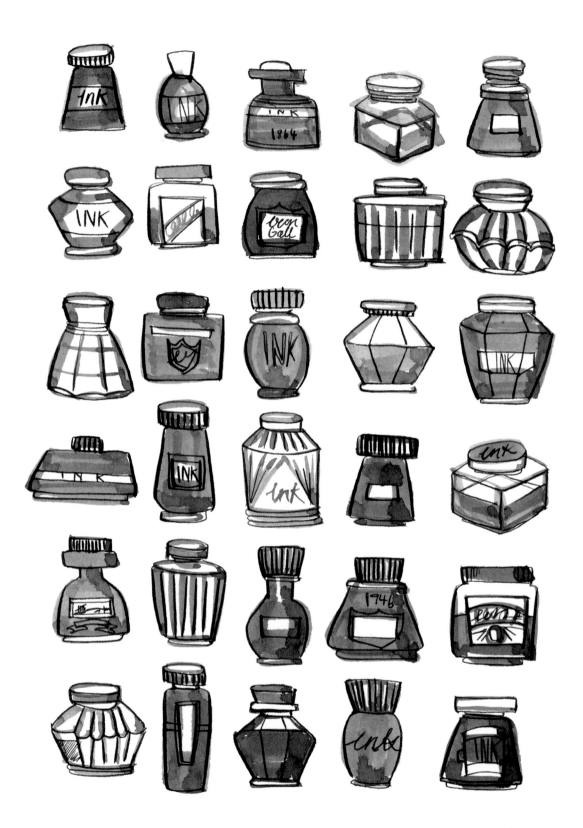

INKY ANTICS

The colour of ink you choose could say more about you than you might realize. Throughout history, leaders, celebrities and artists have used different-coloured inks to signify emotions, orders or business intentions.

Since 1909, the heads of the British Secret Service have always used green ink to sign their letters. Mansfield Cumming was the first head of MI6 and signed his correspondence using simply the letter 'C' in green ink. This became a tradition that was passed down in the role, and is still used to this day.

Virginia Woolf favoured purple ink for her most important writing, including love letters and diary entries. Lewis Carroll also wrote in purple, as he had become accustomed to using it to correct students' work when he taught Maths at Oxford University.

British journalists and politicians often refer to the letters they receive from readers or constituents writing with farcical suggestions or complaints as coming from the 'green ink brigade'. This term came from a trend for these long, passionate and often eccentric letters being penned in green ink.

Alexandre Dumas wrote his 1844 novel *The Three Musketeers* in black ink on a very particular shade of blue notepaper. For Dumas, it was not the colour of the ink but of the paper that he felt affected his writing. He wrote fiction on blue paper, newspaper articles on pink, and poetry on yellow.

Jane Austen penned some of fiction's most famous characters using a quill and iron gall ink. The recipe for the ink, given to her by her sister-in-law, included the instruction that the ink must 'stand in the chimney corner for fourteen days and be shaken two or three times a day'.

In many countries, red ink has an association with death, poor financial status and bad luck. From the writing of death warrants in the dark ages in England to obituaries in Korea, red ink seems to have generally bad connotations. In China, however, red ink historically was considered lucky and was reserved for use by the royal family; anyone else caught using it could be punished with hard labour.

Mixing it up

So now you've got to grips with the basic modern calligraphy lettering forms, looked at angles, height, and the effects different pens and brushes can create, let's start to play with adding other hand-lettering styles.

The elegance of the cursive shapes in the modern calligraphy alphabet mix beautifully with more contemporary modern lettering styles. Here is a chance to play around with your lettering to create powerful compositions packed with character and personality. Let's look at a serif font and a sans-serif font.

Serif fonts have a traditional feel to them. Each letter has a small line – a 'serif' – at an angle to the main stroke of the letter, whereas a sans-serif font has no extra lines, giving it a more modern feel.

By mixing variations of these two styles and modern calligraphy you can allow a piece of text to portray different emotions. Here are some example alphabets, each of which has a very different feeling.

A B C D E F

G H I J K L

M N O P Q R

S T U V W X

Y Z

a b c d e f g h

i j k l m n o p

q r s t u v w x

y z

A B C D E F
G H I J K L
M N O P Q R
S T U V W X
Y Z

a b c d e f g h
i j k l m n o p
q r s t u v w x
y z

A B C D E F

G H I J K L

M N O P Q R

S T U V W X

Y Z

a b c d e f g h

i j k l m n o p

q r s t u v w x

y z

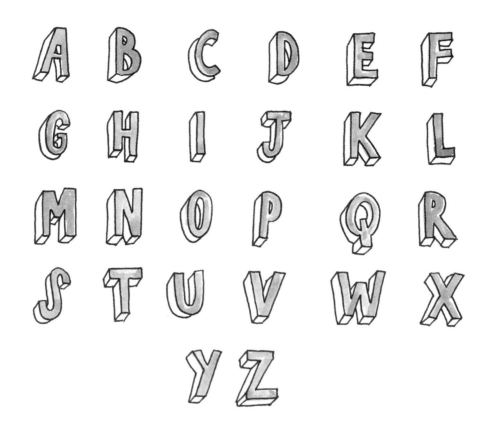

A B C D E F
G H I J K L
M N O P Q R
S T U V W X
Y Z

a b c d e f g h
i j k l m n o p
q r s t u v w x
y z

Here is an example of an Albert Einstein quote that I designed to be used as a wall print or greeting card. I used seven different fonts to give the piece a quirky but informative feel.

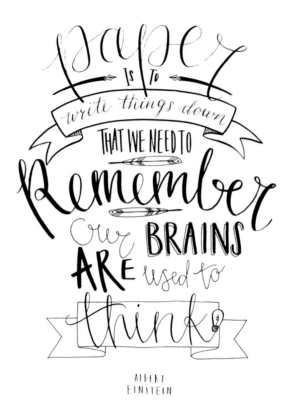

Let's dissect this. Let's look at each of the elements and work through the process I used to create it.

The first thing I do is to write out the quote on a scrap piece of paper several times, deciding which words I will emphasize and which lines each word will sit on. By doing this, you can also see where there are opportunities to join ascenders and descenders from words on different lines or where to place flourishes. When I am happy with the layout, I will use a ruler and compass (or sometimes just the edge of my teacup for curved lines if I'm being lazy) to draw loose guidelines for the lettering.

I decide on the type of letters I am going to use by pairing up different styles: formal with quirky; narrow with bold; ornate modern calligraphy script with plain block letters. It is always my hope that these couplings will come together to create a dynamic composition.

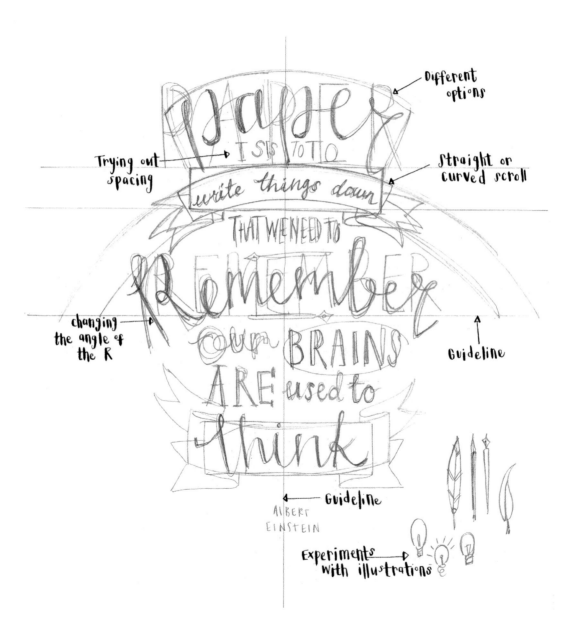

Different options

Trying out spacing

Straight or curved scroll

changing the angle of the R

Guideline

Guideline

ALBERT EINSTEIN

Experiments with illustrations

INKY ANTICS

Have you ever wondered where lost letters go in the mail? All over the world, millions of letters go missing each year and never make it to their intended destination. Some letters will just be bills or bank statements, but others will be declarations of love, photos of new family members, condolences, and old friends trying to patch up a broken friendship. What happens to these tiny human stories wrapped up in envelopes when they can't be delivered?

In the United Kingdom, the Dead Letter Office, dedicated to managing lost mail, was established in 1784. Letters were held at the office for six months if the recipient's name could not be deciphered, then returned to the sender if an address had been given.

Today all the lost letters in the UK are sent to the National Returns Centre in Belfast, which currently processes around 20 million items a year. It is the resting place not only of letters but an eclectic mix of items, including toys, photos, souvenirs, costumes and food! Parcels and letters can arrive simply addressed to 'Geoff' or 'Mr Smith, Cambridge' or to old addresses that no longer exist. Everything is opened and where possible returned to the sender if an address can be found.

In the United States, the Dead Letter Office is called the USPS Mail Recovery Centre. Most mail is sorted by machine and glides through the postal system with no problem at all. But according to a report by Chris Detrick for *The New York Times*, there is still the need for 700 postal staff based in a warehouse in Salt Lake City whose job it is to decipher messy handwriting and try to get badly addressed letters out to their recipients. They not only have to contend with incorrect addresses but also poor handwriting, different languages and smudging.

Who knows how many relationships could have been saved and what secrets were never told over the last 300 years as letters disappeared into the deepest, darkest corners of the Dead Letter Office?

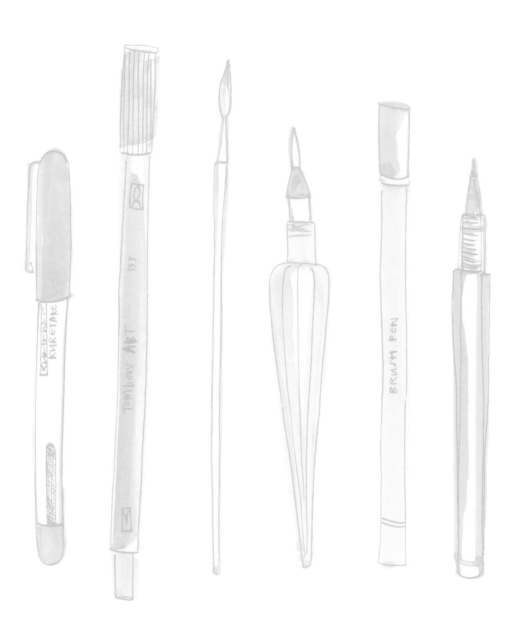

Project ideas

So now you've started to develop your own style, looked at how to add patterns and flourishes, and you're a dab hand at composition, it's time to share your new skill with the rest of the world. You won't always have your pot of ink and pointed pen to hand to write a birthday card on the train or jot down some notes at a meeting, but I've put together some project ideas to inspire you to integrate your new skill into your everyday life and have friends and family marvelling at your beautiful hand lettering.

Over the next few pages you will find ideas for quick one-hour projects, some that are perfect for an afternoon practice session, and a few that will take a little more work to make a lasting heirloom that might be discovered by your grandchildren in years to come.

Have you thought of a different material you can use, or want to try a different kind of lettering style or ink? Fabulous! If we ever get to meet you'll see that I'm quite little, so there are only so many ideas my tiny brain can come up with. Each project is designed as a starting point for your own imagination.

Glorious gift tags

Bring a present to life by creating beautiful hand-crafted gift tags featuring your new lettering skills. There are endless ways to use the bits and bobs hanging out around your desk to make stunning gift tags at relatively little cost. I love creating a range of gift tags every now and again to keep in store for birthdays and events throughout the year. By making a little pile of them in one go you save time in the long run and can economize on materials. A good gift tag can lift a present in simple brown wrapping paper and make it look as if it has been wrapped in a beautiful boutique. Here I have shown you a selection of examples from my archive and chosen one of my favourites, in the shape of feathers, to focus on.

 Select some coloured and white Bristol board card or a similar tightly woven card at least 240gsm for the two sizes of feather.

 Using the templates on page 186 or drawing your own freehand feathers, draw the outline in an HB pencil using the coloured card for the largest feather and white card for the smallest. Try to fit as many feathers on one sheet of card as you can.

 On the coloured feather, use a paintbrush or brush pen to create an abstract patterned design.

 On the white feather, measure out your centre point and draw faint vertical and horizontal pencil lines to help you centre your message.

5 Before you put your message or name on the tag, practise the composition on a scrap piece of paper to decide how to arrange the words. This is great practice for your composition skills to make sure you are creating a balanced look to your wording and that there will be enough room to create a hole to add ribbon to your gift tag. Ink up your nib and copy your composition on to the tag.

6 Leave both feathers to dry fully before rubbing out any pencil guides, then use a hole punch to add a hole at the base of the feather.

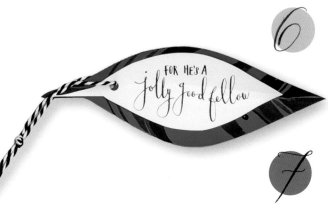

7 To create a more textured effect, when the feathers are dry, turn the feathers over and carefully score a line down the length of the middle, where the quill would be. Gently crease the feather along the line you have scored to give it a 3D feel.

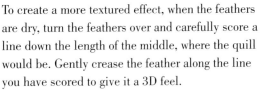

8 Place the small feather with your message on over the large feather and thread through some coordinating ribbon or bakers' twine.

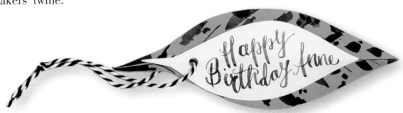

9 You can vary this design by adding more feathers, gluing real feathers to the top or using gold paint or leaf for the tips of the feathers.

Gift bag beauties

This is a quick and easy make to personalize present bags or party bags for children's birthdays, hen nights and baby showers. I have used these to put Christmas cookies in and personalized the front with my family and friends' names. I wrote the recipe on the back as it was a great one I had inherited – I was also hoping someone might make a batch for me one day!

You need to be careful when choosing the bag for this project, as many paper bags will be too porous to use ink on. I used a gouache mix on these bags and a paintbrush to give that lovely chalky writing effect and avoid ink bleeding into the paper or through to the other side of the bag.

 Take a good look at your paper bag and decide how much room you will need to tie it up. Make a small pencil mark on the bag to help you visualize how much space you have to work in, otherwise your design will get gathered up when you tie up the bag.

 Decide what your text will be and, using a piece of scrap paper, sketch out your composition. You could add some floral elements or use a different font, as I have in my design.

 Cut a piece of card from an old cereal box so it is slightly smaller than the bag. Place it carefully into the bag before starting with your paints or ink to make sure nothing bleeds through to the other side.

 If you feel confident, you can start writing freehand onto the bag, or draw a few faint pencil lines to help guide your writing. If you are making several bags in one go you could use Washi or masking tape on your table to mark out a guide for the centre vertical and horizontal lines so each design looks uniform. Place each bag onto this guide so it is in the same place each time you start a new one.

 Write your message, recipe or names on to your bags, checking them from a distance every now and again to make sure your composition looks balanced in the space.

Leave your bags to dry, then remove the cardboard sheets from inside before tying them with a ribbon or string that complements the colours of your design.

You could make a luxury version of these bags by using blank canvas bags and fabric paint.

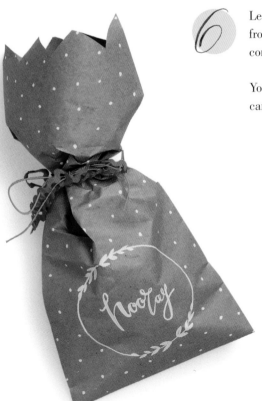

Personalised maps

I came across this idea when I was creating a piece of wedding stationery for some clients. They were keen travellers and wanted something that expressed their love of exploring, so their 'Save the Date' card was written on old out-of-print maps from places they had visited.

Pick a place that is important to you or the person for whom you are creating a gift. Download and print or buy an old map to use as a basis for your design. I found a big pile of gorgeous old maps in muted colours at a flea market in Paris once, and have used them to create little gifts and a print for my studio. Look for maps that ink or paint will work well on. If the map is too porous, you could scan in a section you would like to use and print it out on paper that's more appropriate for your ink. There are also whole libraries full of old maps on the Internet that you can trawl through to find a particular place and print out a section from. For my design, I chose a travel quote and added the place where my friends got engaged. It also works well as a new home gift or a Valentine's print.

 Choose the area on your map on which you would like to create your quote. Think about how your lettering will sit on the page. Don't pick such a busy section of map that your writing will get lost in the design.

 Cut your map or print your selection to your chosen size. Think about how you will mount or frame your finished piece.

 Using a piece of layout or scrap paper the same size as your map, draft out your composition deciding what style you think best suits your quote or personalized message. I have used a combination of modern calligraphy, block capitals and angular brush pen lettering for my design.

 When you are happy with your design, mark up your map in pencil with enough guidelines to make you feel confident about transferring your design. Using your chosen ink, paint or pens, write your design on the map, being careful not to smudge your ink during the process.

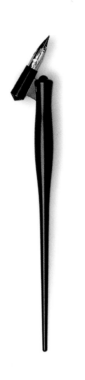

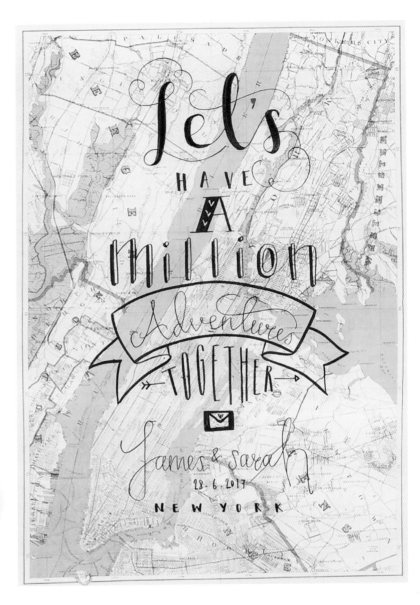

 Wait until the finished design is completely dry before gently rubbing out your guidelines. Take care not to rub too hard with your eraser and crease the paper.

 Mount your design using a pre-cut mount frame or load it into the picture frame you have chosen for it.

 If you are creating a personalized gift, you could add in a section of your old plane ticket to the place you've chosen, a photo of your holiday there, or source some vintage stamps from that country to add to the composition.

Take your place cards

When I was little I used to make these for special family meals. Even though it would just be my parents, brothers and sister around the table, I loved the formality of it. I think I had only seen them at weddings so thought they made a meal super special, and if I'm honest, I still feel a little bit like that today! There is something so exciting about seeing a beautifully laid table with everyone's names there waiting for them. Here's a collection of some of the place cards I have designed for Betty Etiquette clients. Each one tells a little story about the type of people who ordered it and the style of the event.

So what's the difference between place cards and escort cards? Place cards for an event or wedding will be placed on a specific allocated seat for each guest at a table. To accompany these, guests will need a table plan or seating list to find their name and allocated table. Escort cards, however, are presented on a table close to the entrance of the dining room. Each card will have your guest's full name and the table number they are sitting on, but no place. Your guests pick up their card and take it to their table, selecting their own seat once they arrive. So place cards are more formal as you can decide exactly who's sitting next to whom, and make sure randy Great Aunt Edna doesn't end up sitting next to the vicar!

Place cards don't need to be folded; they can rest in the centre of the place setting, be tied around the stem of a wine glass or placed in a themed holder such as a cork or pinecone. They're a fantastic way of adding colour to a table setting and showing off your lettering skills.

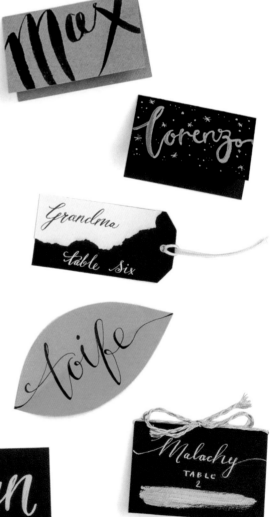

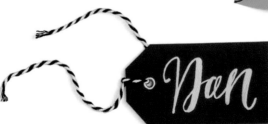

148

Top tips for lettering on place cards:

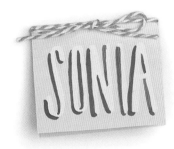

Practise a few different lengths of names on some samples of your chosen shape to decide on the layout for your place cards. Try to get a uniform look by always placing the name in the centre, no matter how long it is.

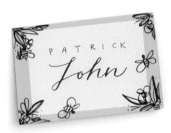

Experiment with different lettering styles for first names and surnames.

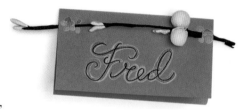

If you have a nature-based aesthetic for your wedding, try using different materials such as shells, driftwood, pebbles or sliced logs to write on with a paintbrush. You can use acrylic paint or purchase a few interior paint tester pots from a DIY store. Make sure you use a legible colour combination.

Delicate pastel colours are beautiful, but need to be bold enough for people to read from a distance away.

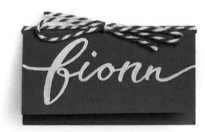

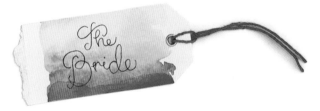

Think carefully about the time it is going to take you to write out your place cards. An elaborate design might be OK for a dinner party of eight, but could prove to be a challenge for a 120-person wedding in the middle of your last-minute preparations.

Keep flourishing in your lettering to a minimum to allow people to read their name clearly.

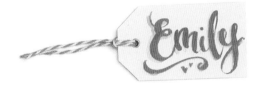

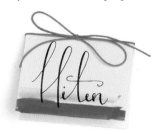

Always make a few spare place cards in case there is a last-minute guest change. Even if you don't have your nib and ink to hand, you can use a felt-tip pen in the same colour to simulate the style.

The art of the envelope

My Christmas cards would take a lot less time each year if I hadn't started decorating the envelopes along with writing the cards! I love putting a pile of cards in the post with lavishly designed envelopes; I know that when they arrive at their destination they will leap out as something exciting to open in the middle of a pile of bills and takeaway menus.

I find writing on envelopes really rewarding. They are a small surface area to work on, so quite quickly you can create unique little works of art that are also functional. The biggest problem for me is making sure that I don't make the design too elaborate and risk the actual address not being visible!

When it comes to wedding invitations, envelopes can be a very serious business, from the design right down to the postmark. Brides from all over the world fly to a tiny post office in Oregon in the United States to have their wedding invitations stamped by the staff there. This may be one of the smallest post offices in the US, but it is one of the busiest due to its location in a town called Bridal Veil. Each envelope that passes through the counter there gets hand-stamped with a postmark from Bridal Veil with the date. For the bride-to-be looking for the ultimate invitation to their wedding, this is the perfect finishing touch.

Although I encourage you to let your imagination run wild on your envelopes, make sure you check the following things before you pop your letter in the post.

- Don't tape anything over your stamps, as the machine that processes the letters will not be able to register that stamps are attached.

- It is fashionable at the moment to apply several stamps to envelopes to add to the aesthetic. For example, you might make up the cost of your postage with three or four lower-value stamps that use floral designs to echo the floral motifs you have used in your lettering. I'm sure this looks beautiful, but, ultimately, the letter needs to reach its destination, and now you are probably relying on nice postal workers who are not having a horrid day at work and slept well the night before to help you out. They will probably have to process this letter by hand to get it through the system. To try to increase the chances of your letter arriving, make sure the stamps add up to more than the actual cost of the letter you are sending so there are no issues with the price.

- Glossy envelopes or ones using mirror board are hard for postal machines to read, and ink can rub off them on their journey to their destination.

- Above all make sure that the address is legible. The postcode or zip code needs to be really clear, and always add a return address to the back of the envelope.

- If you add any 3D embellishments to the outside of your envelope make sure this does not make the letter too thick to be posted as a standard letter, or adjust the postage to accommodate this.

- If you have used lots of ink or paint, don't put your envelopes in the postbox when it has rained that day! I can speak from experience that one little raindrop lurking on the rim of the slot can do a great deal of damage to your beautiful designs.

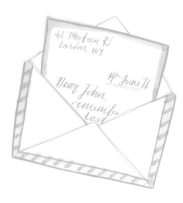

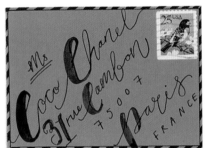

Ms Coco Chanel
31 rue Cambon
75007
Paris
FRANCE

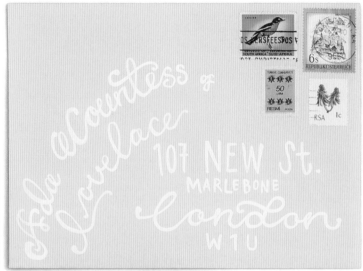

Ada Countess of
Lovelace
107 NEW St.
MARLEBONE
London
W1U

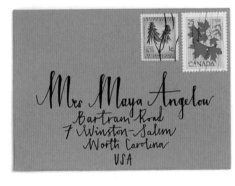

Mrs Maya Angelou
Bartram Road
7 Winston-Salem
North Carolina
USA

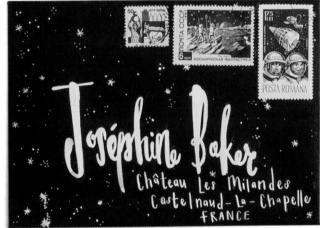

Joséphine Baker
Château Les Milandes
Castelnaud-La-Chapelle
FRANCE

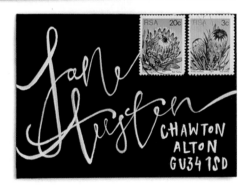

Jane Austen
CHAWTON
ALTON
GU34 1SD

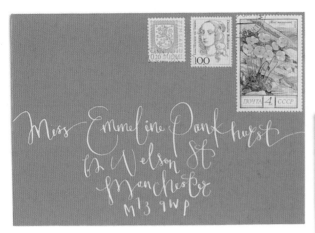

Miss Emmeline Pankhurst
62 Nelson St
Manchester
M13 9WP

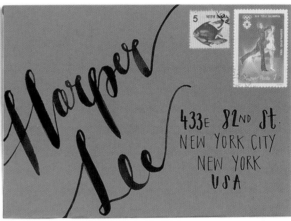

Harper Lee
433E 82ND St
NEW YORK CITY
NEW YORK
USA

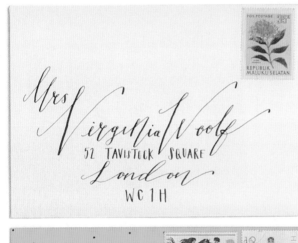

Mrs Virginia Woolf
52 TAVISTOCK SQUARE
London
WC1H

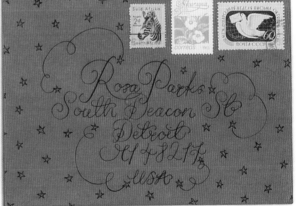

Rosa Parks
South Deacon St
Detroit
MI 48217
USA

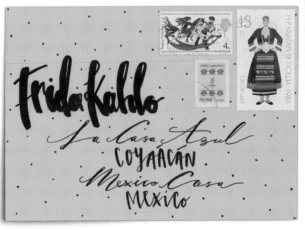

Frida Kahlo
La Casa Azul
COYAACAN
Mexico Casa
MEXICO

Here I have shown you a range of envelopes that I have experimented with using different lettering styles, colours and pens. As with all of your lettering projects, think about what ink or paint is suitable for your envelope so as to avoid bleeding or smudging. You will have less choice over the type of paper your envelopes are made out of, as most come in standard weights and finishes. But you still need to be careful when using Kraft paper, very porous cotton or linen-style envelopes, or recycled envelopes, as they can all soak up the ink too easily.

When producing a single envelope or a few envelopes for friends, consistency is not a problem. You can vary the design from person to person, and they won't know that your Christmas card envelopes were all slightly different. But if you are creating envelopes for a wedding or client and all the addresses need to have a uniform appearance, there are a few things you can do to help save time.

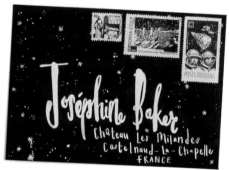

Take a spare envelope that matches those that you want to send, and plan out your composition in pencil. This will act as your master copy to which to match your others. Decide on the height and style of each line of the address, allowing for variations for long and short addresses. The key here is to decide which styles you will use for which lines and stick to this, even if you have to use seven lines for one address and four for another. Another big decision about your composition is whether you should centralize your text, left- or right-justify it, or create something completely individual with angles or curves. Look at a few of my examples to inspire you and try playing around with ideas in pencil on scrap paper before committing to drawing your final design. Once you have a final composition, draw a version of your guidelines on your master envelope, measure the distance between the lines, and write out the measurements clearly. Using this master as a guide, copy the guidelines lightly in pencil on to each envelope. Once you have carefully written all your envelopes and added any additional illustration, stickers, Washi tape or stamps, leave to dry thoroughly before gently rubbing out your guidelines.

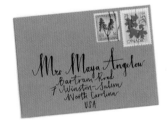

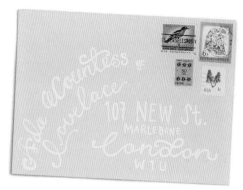

 Alternatively, you can make an envelope address stencil to help you space your address perfectly across a large number of envelopes. As with the simple pencil guidelines method, start by sketching out what you want the design of your envelope to be. This time you need to create guidelines for the lettering to sit on but also show the space between each line. In this way you will end up drawing small horizontal boxes with gaps between them; these boxes are where your writing will sit. Copy this out onto a piece of sturdy card cut to the same size as your envelope. Using a craft knife, cutting board and ruler, cut out the boxes where the writing will sit, leaving behind a solid template that you can place over a blank envelope and write within. You can reuse this template on any envelopes the same size or make new templates for bespoke-sized envelopes. To get you started, I have drawn you a template for a standard C6 (114 × 162mm/4½ × 6½in) envelope on page 186 that you can trace and transfer to a piece of card.

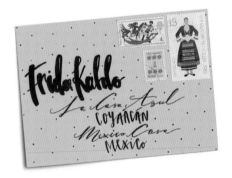

 For light-coloured envelopes you could invest in a cheap light box. This will allow you to place the envelope over a set of guidelines, which will be visible through the envelope. If you have caught the lettering bug and are going to continue practising your new skills, a small light box would be a great investment. Add illustration, stickers, metallic tapes, glitter or rubber stamp prints to your envelopes to depict seasons, special celebrations or hint at the message that lies within.

Beautiful banners

This quick and easy make is a great way to show off your lettering on a big scale. Whether you want to make a welcome home sign, announce an engagement or celebrate a brand new baby in the family, this banner will add a personal touch to your event. You can make it using one single-colour card, or mix it up by using old wrapping paper or even fabric offcuts glued on to corrugated cardboard.

 On a blank piece of scrap paper, draw a single pencil line across the page and write out the message you want to appear on your banner. The length of the message is up to you; you just need string or ribbon long enough to hang all the words.

 Now you have your message in front of you, draw another line across the page that touches the top of the letters like 'e', 'o' and 'n'. This is where your string is eventually going to hang, so as you draw each letter you need to think about where two holes will be placed to allow the string to thread through.

 Below this on your paper, sketch out the shape of the letters that you want. You could pick a block lettering style, a modern calligraphy style or mix them together, as long as there is room on each letter for the string holes. It might help to write them first as full words, then break them down to single letters.

 Take your chosen card and paper and cut it into rectangles, making enough for each of the letters in your banner message. I used rectangles 15 × 10cm (6 × 4in) for the banner in the picture.

 Now it's time to scale up your letters on to the cardboard rectangles. Using a pencil or soapstone pen for dark-coloured card, lightly draw out the outline of the shape of your letter on to the cardboard, making each line thick enough to withstand being cut out and punched. If you have chosen a cursive script, you could add in the connecting lines that will help give the idea of the letters flowing through the banner. Try to keep your letters a consistent size, so all letters with ascenders like 'b', 't' and 'h' are roughly the same height.

 Once you have sketched out all your letters, cut them out carefully using a craft knife and cutting board. Be careful when removing the centre of letters like 'd' so you do not cut through the loop of the letter. Rub out any remaining guidelines on the letters.

 Arrange your banner letters on the floor as you would like them to be spaced. Lay a piece of string over the letters where they will hang and make two pencil marks where you will make holes for the string to thread through the letter.

Using a hole punch or craft knife, carefully make the holes and string the letters on to your chosen ribbon or twine, making sure you leave enough ribbon at the end to hang up the banner. To prevent the letters bunching together on the ribbon when it is hung up, secure the letter in position on the string with a little sticky tape on the back of the letter.

I've added some paper stars to my banner; you could also use balloons, pompoms, photos of the person you have made the banner for, or tissue-paper streamers.

An invitation to...

Here's a little project to help you whip up some invitations for your next soirée. Whether it is a New Year's Eve party, baby shower or birthday bash, these invitations are quick to create but will set the tone for a fabulous party. By adding the tracing paper layer you can insert confetti, sequins, buttons or even flower petals to the inside to hint at the kind of party you're planning. The New Year's Eve invitations shown here are A6 (105 × 148mm/4⅛ x 5¾in) in size but you can scale them up or change the shape to fit in a DL envelope (99 × 210mm/8⅔ × 4⅓ in).

 Select a stiff card stock (220gsm and above) in your accent colour for your invitations. The card needs to be plain with no patterns or design on it so the confetti will show through under the wording. Cut your card into A6 pieces, making enough for your invitations and perhaps one spare to experiment with before you start gluing. These will form the front page of your invites.

Repeat this process to create a back page for each invitation in the same A6 size. For this you could use a contrasting colour, or for these New Year's Eve invites I used a black card to give them a crisp finish that I think suits the occasion.

 Cut your tracing paper into A5 (148 × 210mm/5¾ x 8¼in) sheets, enough for one per invitation. Place a sheet of tracing paper on the table and lay one of the A6 card sheets on top of it, right in the centre of the sheet. Using a pencil, lightly mark the tracing paper to show where the corners of the coloured card sit. Cut out the corners of the tracing paper to meet these marks, leaving you with a tab on each side to fold around the coloured card and glue at a later stage.

 Before you start writing your design onto the tracing paper sheets, plan out the composition on a piece of A6 scrap paper. Be careful to think about where the confetti will show through and make sure your design isn't too busy to make this effect work. I used a Tombow ABT black pen and white gouache paint for my design. Acrylic paint, gouache paint and many ranges of felt-tip and brush pens will work on tracing paper, but to make sure the materials you have chosen won't bleed or smudge, try them out on some of the offcuts of the tracing paper first.

 Add your chosen lettering to the tracing paper sheets, repeating your design until you have enough, then leave to dry. While they're drying, divide your confetti up so you have equal amounts for each invitation.

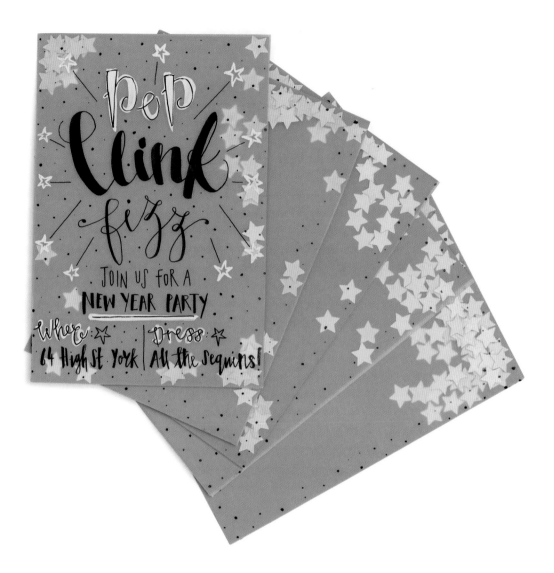

 Once dry, turn the tracing paper sheets over so the lettering is facing down. Now place one A6 front card sheet on to the paper, to match up with the corners you cut out earlier. Using a glue stick, carefully fold over and stick the two long edges and one short-edged tab down onto the coloured card. Pop the confetti into the pocket you have created between the tracing paper and card, then stick down the final tab.

 Now you just need to neaten up the back of the invite. Carefully glue and attach the second piece of card to the back of the invite. This should hide the gluey tracing paper tabs and give your invite a spotless finish. Repeat for all your invites until you have a lovely stack of party particulars ready to go. Make them stand out as they fall through the letterbox by using your hand-lettering skills to bring the envelope to life too.

A lot on your plate lettering

I love digging around in vintage shops and markets to find interesting pieces of old china to write on. There are great pens and paint readily available now that mean you can easily use your lettering skills on porcelain, glass and metal. You simply use a domestic oven to fix the paint, making it dishwasher-safe. I have used my hand lettering on vintage teacups for a friend's bridal shower, made commemorative plates for wedding gifts, and personalized plates for a client's 40th birthday party. I used the Marabu Porcelain pen but you can use a black Sharpie. Once you get to grips with the flow of the pen you'll find it hard not to write on everything in your kitchen! To make wall decorations like the ones here, follow these simple steps.

 Root through your local charity shops, vintage stores and eBay to find a selection of plates that are slightly different sizes but share a common colour or motif. I have used five, but you can collect as many as you need to fill the space on your wall.

 Clean your plates well and make sure they are dry before starting work on them. Arrange them in the way in which you will ultimately display them so you can see how the words will have to flow from one plate to another.

 Choose your quote or passage from a book that you would like to write on the plates. On a scrap piece of paper, decide which sections you would like to be on each plate. The Marabu Porcelain Painter Black pen that I have used can create quite delicate lines, but it is still much thicker than the lines your pointed pen will create, so make sure you leave enough room on each plate for your chosen text.

 If you are confident, you could start straight on to the plate with your porcelain pen and use a freehand style for your writing. If you would prefer to plan out your lettering, draw around each plate on a piece of paper and devise your composition beforehand.

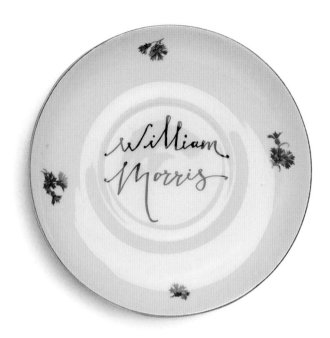

 Before you use your pen, give it a good shake and check the flow by trailing it on a piece of paper or cardboard. These pens can be prone to creating paint bubbles as you write with them, so I always quickly test the pen on the cardboard each time I am starting a new word.

 Once your plates are dry, they are ready for the oven. Read the instructions that come with your pen to adjust times to your particular oven, but in general you need to bake the plates for 30 minutes at 160°C (320°F), then leave to cool.

Work across your plates in order, in case you have to move some words around through the process. I used black paint as I like the simplicity of it, but there is a vast range of paint colours available if you want to add colour to your project.

 Your plates will look magical displayed on a shelf, or you could attach them to the wall with wire-plate wall mounts.

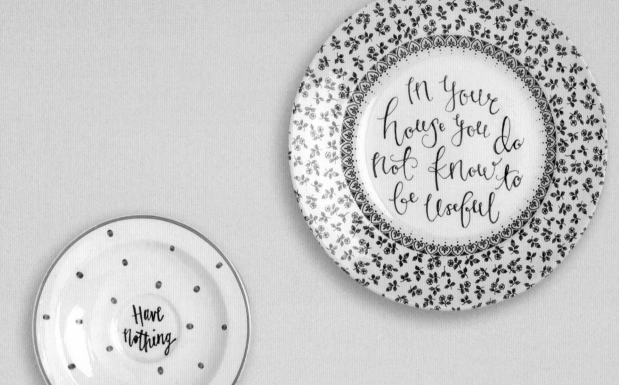

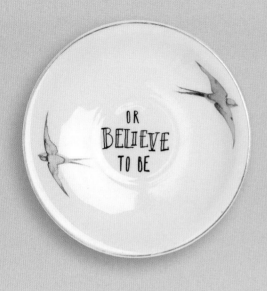

OR
BELIEVE
TO BE

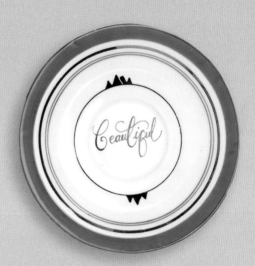

Beautiful

William
Morris

It's a wrap personalised paper

This is a simple but very effective way to personalize a gift. Make sheets for all your family at Christmas in an afternoon craft session and observe their delight as they find their personalized presents under the tree.

 Using A2 (420 × 594mm/16½ × 23½in) brown Kraft wrapping paper sheets or coloured paper in the same size, decide on the style of lettering and type of pen or brush you would like to use. You will need to cover quite a lot of space with your lettering, so using your pointed pen for this project won't work well on the paper.

 Write the name of the person for whom the wrapping paper is intended on a piece of paper nearby. It is easy to get the spelling wrong when you are repeating the same word over and over again, so it's handy to have it written out in front of you.

 I think the messier and more organic the letters are for this style of project, the more effective it looks. For once, don't worry about practising your lettering first; just get started straight on the paper.

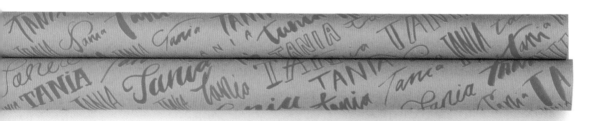

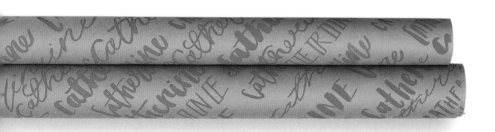

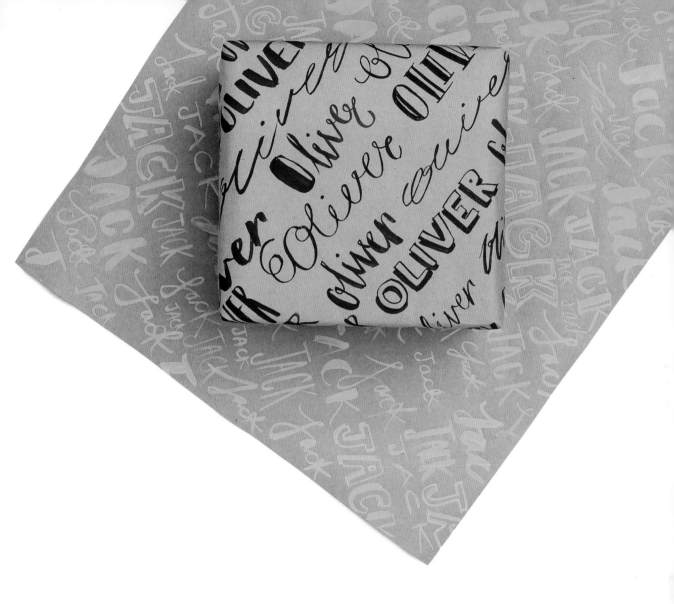

 Write your first line of text across the full diagonal of the paper to act as your guide for the rest of the sheet. Work away from this point above and below in full lines. Fill up the whole of the page using half-words and single letters when you get to the final corners. Decide if you would like to add any glitter or metallic paint to the sheet, perhaps picking out a letter or the dots on an 'i' or 'j'.

 Leave the sheet to dry thoroughly; then it is ready to use.

 Finish off this beautiful parcel with coordinating ribbon or string, and perhaps one of the feather gift tags on page 142.

A capital gift idea

This is a lovely gift for a new baby or a friend who has just moved house. It will really test your composition skills as you try to balance your words to create a solid enough shape to recognize the large letter, while also being able to read the text within. I chose to draw a letter S for my friend Silvie and used quotes from *Pride and Prejudice*, her favourite novel, to fill in the shape. If you are creating a print to put in a frame, you will only need thin card or paper; if you are making a print to go directly on the wall, you will need stiffer card for your project. I have made an A4 print (210 × 297mm/8¼ × 11¾in), but you can scale up the design using a photocopier.

 Decide on the letter you are designing and the text you will use for it. Have it written out somewhere on your desk nearby.

 If you feel confident drawing out the outline of your letter freehand, then brilliant, get cracking. But if you need a guide at this stage, print out a capital letter in your chosen font in the largest size your margins will allow on an A4 piece of paper. Pick a font with a thick, solid shape such as Arial Black, Impact in bold or Rockwell Extra Bold.

 Once you have your printout, if you are using thin, light-coloured paper you can place this over the letter printout so you can see the shape through it. If you are using dark-coloured card or thick white card, cut around the printed letter and draw around it with light pencil marks or soapstone on to your chosen card.

 When you are happy that you have filled the letter enough that it is balanced and clear, leave the project to dry, then rub out any guidelines if you used them.

 Now you have an outline of a letter shape to work with, you need to fill the shape with writing dense enough that when you stand back from the picture you will recognize the letter you have created. Work across the letter using your chosen text, trying to keep words whole and using ascenders and descenders to help you build the shape of the main letter. I have used a mixture of hand-lettering styles, but you could pick just one to use throughout the composition.

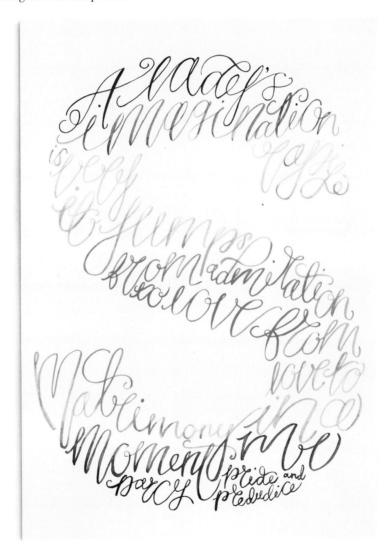

 You could add glitter or gold leaf to the finished design to add some texture to it, or pick out key words in another colour to share a hidden message with your recipient.

Stamp it out

A great little present for a friend, or for yourself for that matter (the best kind of present!) is a personalized rubber stamp. I like to make these for my wedding stationery clients as a little secret surprise in their box of goodies, as I know how useful a stamp can be. Turning your designs into a format that can be used to make a rubber stamp is easier than you think. Whether it's your address or a friend's children's names, think of it like a little logo for them and create a strong, clean design that will look good when used on lots of different surfaces. Modern calligraphy styles lend themselves perfectly to rubber stamps, as the style complements the handmade feel of the stamp. Here's how to create your own.

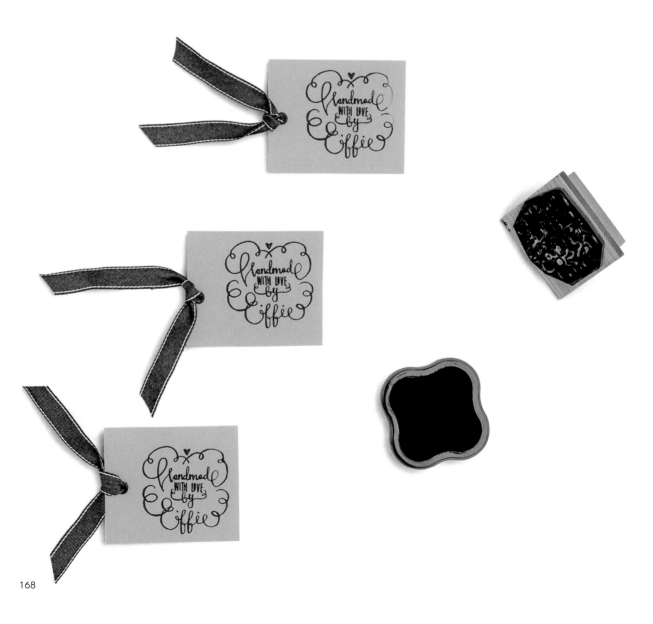

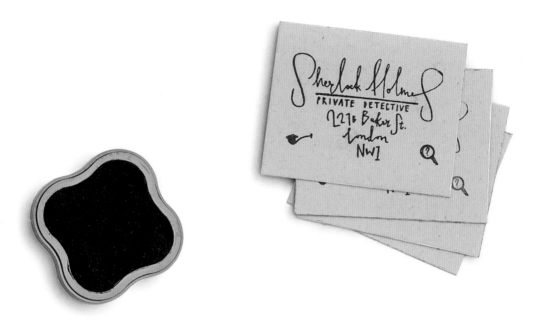

 Decide on the text you want to use for your stamp and any motifs or borders you would like to add. Using a pencil on a plain piece of paper, sketch out the writing, thinking about composition.

 Add any flourishes or illustrations, being careful not to obscure the text. Give your lines space between one another; don't bunch words up too closely together or place borders very near the lettering. This will help get the best out of the print when it is turned into rubber.

 Once you are happy with your design, place a clean piece of layout paper over your design and use a clipboard or masking tape to secure them as you draw. You could also use a light box for this process.

 Using your pointed pen, trace over the design in clear, crisp lines; be careful not to smudge or drip ink onto the finished piece. When it is dry, put your design in your scanner and scan to at least 300dpi, and ideally 600dpi.

 If you are a Photoshop or Illustrator user, you will be able to import, crop, tidy up and save this image as a jpeg. If not, you can still scan the file directly from the machine as a jpeg and use the software on the stamp company's website to do the rest.

 You can find your nearest rubber stamp manufacturer easily through a web search. There are also many listed on Etsy and Folksy. Most manufacturers will also have inkpads available in their shops. Upload your jpeg through their website and begin counting down the days until you can start stamping anything that stays still long enough!

To obtain a different effect from your stamp, try using embossing powder, ink and a heat tool to create beautiful raised metallic designs.

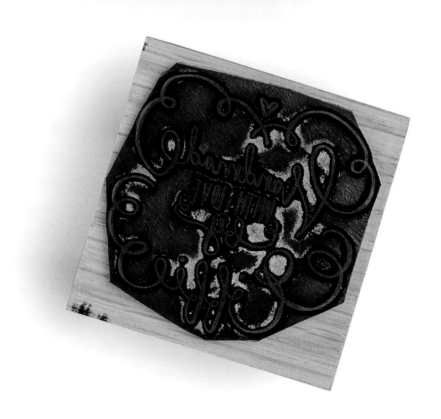

BEST DAY EVER

Michael AND *Caitlin*

Let there be love

EAT DRINK and BE

Married

Large lettering for events

Working on a large scale with your lettering can be a really exciting new experience. For this project we'll be using brushes and working on fabric with fabric paint. You can create a banner for events, home decoration or a gift. As fabric is really durable, you can easily roll it up and store it for the next time it's needed.For my banner, I chose an off-white thick canvas fabric measuring 85cm wide × 105cm long (33½ × 41¼in). You can pick this up from a haberdashery, or it is available widely online. If you have a sewing machine you may wish to hem the fabric, but I chose to fray the edges slightly.

 Using an A3 (30 × 42cm/11¾ × 16½in) piece of paper, rule up a central line and plan out the composition for the text you have chosen for your banner.

 On your fabric, measure out the centre line running vertically down the fabric. Mark the line with pins or masking tape. This line will help you to scale up your design, keeping it balanced. Make sure you leave at least 5cm (2in) at the top of the fabric without any design on so it can be used for hanging the banner once you have finished.

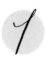 Using a 48-hour-fade fabric pen, copy out your lettering outlines ready to fill in with fabric paint.

 Mix up or select the fabric paint colour of choice for your lettering. Begin to carefully work across and down the banner to fill in the letters you have sketched out with a paintbrush.

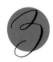 Once you have finished, leave the banner to dry for two days, by which time the guideline you drew will have faded. Most fabric paints can be fixed by ironing them once dry, but check your chosen fabric paint box for detailed instructions.

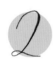 Cut a piece of wood dowelling 90cm (35½in) long and staple gun or superglue it to the top of the banner, leaving 2.5cm (1in) overhanging each end. Tie ribbon or bakers' twine around the end of the dowelling to hang the banner.

Calligraphy and cakes: the perfect combo

This is a great way to make a regular homemade cake or cupcake feel a little more like a prize-winning specimen. Just creating one of these to go on a shop-bought cake (throw a bit of icing sugar on the cake and on your face – I won't tell anyone you didn't bake it yourself) will make someone's birthday really special. All you need is some card suitable for the ink you want to use and two wooden kebab skewers.

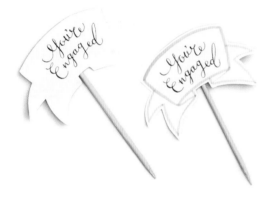

1 Measure the width of the cake for which you are making a topper. You will need to draw a template at least 4cm (1½in) smaller than the width of the cake at its widest point.

2 Decide upon your message and begin to sketch out your design onto some scrap paper. Using the method for adding motifs we covered on page 104, draw a scroll and floral border for your message at the correct size for your cake. If you are not confident about drawing a border, there is a template on page 187 that you can trace over with layout paper. Once you have the outline, turn the paper over and, using a pencil, draw over the lines so they are all covered. Flip the layout paper back over, place it on the card you have chosen and draw over the line once more. This will leave you with a faint outline of the topper design template for you to work with.

3 When you are happy with your final design you can either get started straight on to your paper with your pen, or draw a faint version of your design on your card as a guide.

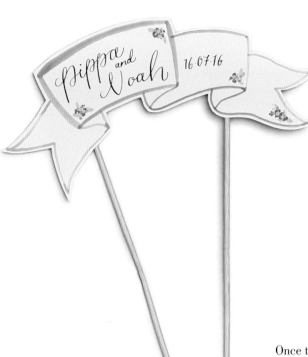

I used watercolour paints to highlight a small section of the design before using my pointed pen to go over the whole design and fill in the message. You could also use gouache, acrylics or coloured brush pens.

Once the design is completely dry, erase any guidelines or pencil marks and carefully cut around it, leaving a border of roughly 5mm (¼in) all the way around. This will be the front of your topper.

Once you have cut out the front, place it on to a matching piece of blank card and draw around the edge. Cut out this shape so you have a blank version of the topper for the back.

Place your back piece on the table and use masking or paper tape to secure the top of your two wooden kebab skewers to either end of the topper, roughly 2cm (¾in) in. Cover the rest of the back in glue and gently press together with the front until it is completely stuck. Allow the topper to dry fully before adding it to your cake. If the skewers are too long once your topper is in the cake, trim them slightly to bring them down closer to the surface.

You can adapt these toppers for both cupcakes and full-sized cakes. They also work well for labelling cheese boards or herb pots.

The big day

I often have brides-to-be, mothers of the bride or bridesmaids coming along to workshops
hoping to learn modern lettering for upcoming weddings. Handwriting some elements is a great
way to add personal details to your big day. But where do you start?

The first thing I do when I meet clients to discuss their wedding invitations is try and get a
sense of the feeling that they want to portray to their guests. Once you've decided on your
style, a central colour theme will also help to tie everything together. Pick a main colour,
but also think of two or three accent colours that compliment this. For example, blush pink
could be your base colour, with copper, dove grey and cream as accent colours.

Once you have the feel and colour defined, think about what kind of
paper or card works for your style. Perhaps if it is a rustic wedding you
could use Kraft paper, or a modern city wedding might lean towards
thick luxury card with deep, crisp edges. Then it's time to think about
the style of hand lettering you are going to use and whether you will use
your pointed pen, a paintbrush or brush pens. What style will portray
the feeling of the celebration? You could even try a combination of
styles.

Decide on what you want your
wedding stationery to include.
Will you send a 'Save The
Date', an RSVP card, a map of
the venue, or accommodation
details for your guests? Once you
know how many elements you
will be making you can begin
experimenting with different
materials.

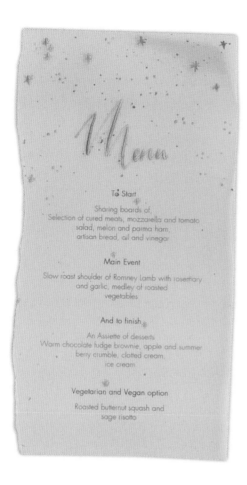

When guests receive their invitation you want it to feel like an envelope full of jewels: bold lettering, exciting textures and colours to share the news about the plans for your big day! But most importantly, the invitation needs to supply your guests with all the information clearly; your lettering needs to be decorative but dates, times and any calls to action need to be easy to read. You can reference your style on the day by using the same design and lettering for your place cards, signage, menus and table names.

The example I've chosen to share here is from a client who was holding an evening wedding ceremony and ended the celebrations outdoors with sparklers and fireworks. They wanted to capture a magical, night-sky aesthetic with navy as their central colour. I used my pointed pen and Finetec Inka Gold paint and coupled it with printed text in a Futura Light font. I kept the detailed sections in printed text to allow them to be easy to read and made the titles and names more elaborate. This is just one example to get your creative juices flowing. Here are a few tips to add lettering to your own enchanting invitation suite.

Experiment with different lettering styles using a few of the guest's names to help you decide on your final look.

Use your lettering skills to create envelope liners, making regular, low-cost envelopes look far more glamorous.

Try metallic pens and inks or even invest in embossing powder, a pen and a heat tool to add a little extra personality to your designs.

If you are mixing printed text and hand lettering, always print the text first to avoid your paint or ink getting stuck on the printer rollers.

If you are adding embellishments, buttons, twine or ribbon, make sure your lettering is complete and dry before applying them.

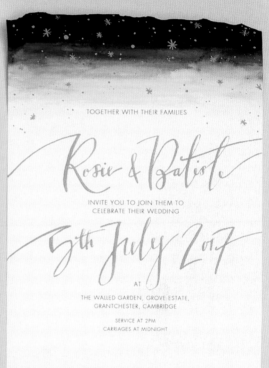

TOGETHER WITH THEIR FAMILIES

Rosie & Batiste

INVITE YOU TO JOIN THEM TO
CELEBRATE THEIR WEDDING

5th July 2017

AT

THE WALLED GARDEN, GROVE ESTATE,
GRANTCHESTER, CAMBRIDGE

SERVICE AT 2PM
CARRIAGES AT MIDNIGHT

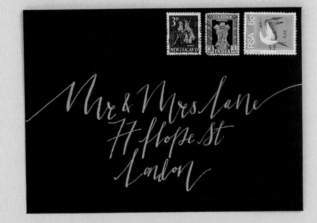

Mr & Mrs Lane
77 Hope St
London

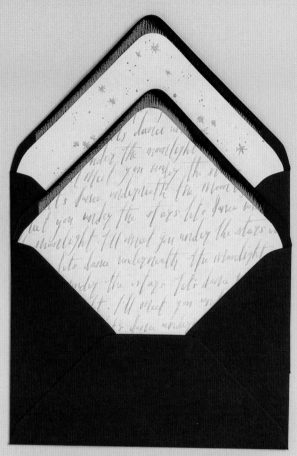

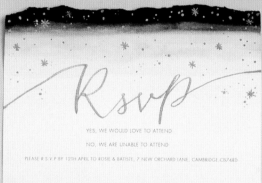

RSVP

YES, WE WOULD LOVE TO ATTEND

NO, WE ARE UNABLE TO ATTEND

PLEASE R.S.V.P BY 12TH APRIL TO ROSIE & BAPTISTE, 7 NEW ORCHARD LANE, CAMBRIDGE, CB74RD

Menu

To Start

Sharing boards of:
Selection of cured meats, mozzarella and tomato
salad, melon and parma ham,
artisan bread, oil and vinegar

Main Event

Slow roast shoulder of Romney Lamb with rosemary
and garlic, medley of roasted
vegetables

And to finish

An Assiette of desserts
Warm chocolate fudge brownie, apple and summer
berry crumble, clotted cream,
ice cream

Vegetarian and Vegan option

Roasted butternut squash and
sage risotto

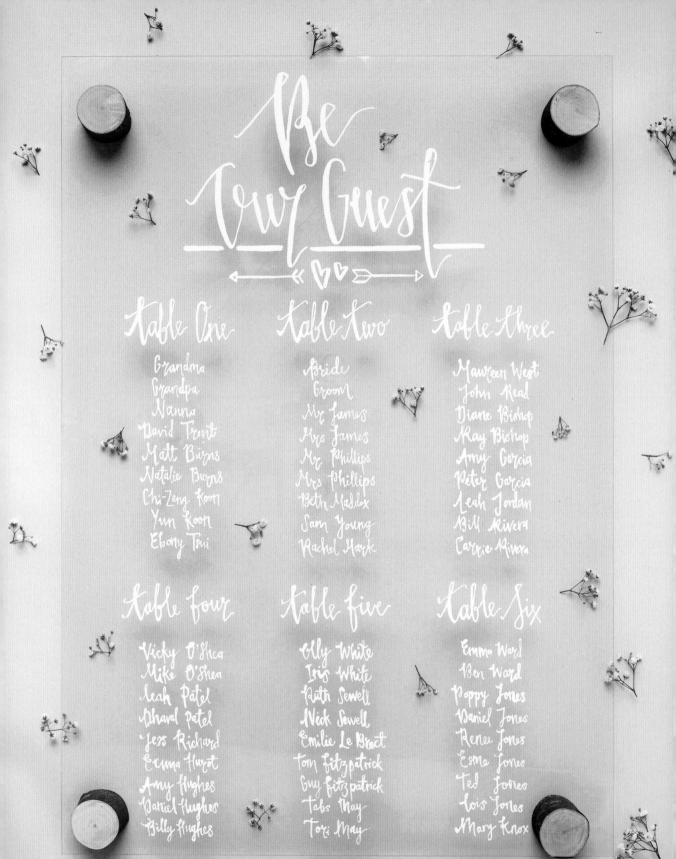

Be Our Guest

Table One

Grandma
Grandpa
Nanna
David Trent
Matt Burns
Natalie Burns
Chi-Zeng Koon
Yun Koon
Ebony Tsui

Table Two

Bride
Groom
Mr James
Mrs James
Mr Phillips
Mrs Phillips
Beth Maddox
Sam Young
Rachel Mark

Table Three

Maureen West
John Read
Diane Bishop
Ray Bishop
Amy Garcia
Peter Garcia
Leah Jordan
Bill Rivera
Carrie Rivera

Table Four

Vicky O'Shea
Mike O'Shea
Leah Patel
Dhaval Patel
Jess Richard
Emma Hurst
Amy Hughes
Daniel Hughes
Billy Hughes

Table Five

Olly White
Iris White
Ruth Sewell
Nick Sewell
Emilie Le Breet
Tom Fitzpatrick
Guy Fitzpatrick
Tabs May
Tori May

Table Six

Emma Ward
Ben Ward
Poppy Jones
Daniel Jones
Renee Jones
Esme Jones
Ted Jones
Lois Jones
Mary Knox

Sensational see-through script

I remember the first time I did this for a client's wedding: I was so scared that it wasn't going to look balanced that I measured everything about 15 times. When I finally pulled off the guides to reveal the text I was so glad it was all straight, I didn't notice I had got the date wrong until one of the bridesmaids pointed it out to me at the venue! Thankfully, I learnt that this process isn't as hard as it looks, and the paint used is washable so I was able to quickly amend the date without anyone else seeing. This is a fantastic way to bring together lots of the key skills you have learnt in the book and make a show-stopping piece that could be used at weddings, for birthday parties, or to make small personal gifts. To recreate this project you will need an A2 (420 × 594mm/16½ × 23½in) clear Perspex acrylic sheet, A2 layout or tracing paper, and white Uni-ball Posca pens.

Using your final table plan list, look at how many tables you have and how long each list is to help you decide on the composition of your project. I needed just six tables on my example and the guests were equally divided amongst the tables; but you may have some small and some large table lists. Using scrap paper, play around with where you want to place each table list and where the title of the board will go.

Once you're happy with the arrangement of your lists you can move on to your A2 card or paper. You will be drawing the final design on here first, before using it as a guide underneath the Perspex sheet. Use a ruler to measure out the central vertical and horizontal lines and plot out how much room you want to use for the title section. Draw a box or guidelines for your title.

Moving on to the lists of tables, measure out how much room you have left underneath the title and divide it between the number of lists you have. Be careful to think about how big the titles will be and how much room you want between each set of names. When you are happy, draw a light pencil box to show each section and mark up guidelines for the number of names you need.

Create a pencil draft of the full lettering design in the title, table names or numbers and all the guests' names. This is the time to play around with the spacing if you're not happy with it, rub out sections or names until you are entirely confident about the overall look. Don't forget to keep standing back from your work so you can look at the design in full.

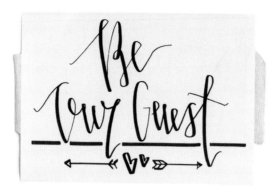

 On my example project, I then cut out the table sections and title boxes, as I wanted to be able to play around with the layout as I went. You can keep your A2 page as a whole image or cut out the boxes, depending on how confident you are that you can line them up again by eye on your Perspex.

 Using masking tape, secure your design to the back of the Perspex sheet with the writing showing through. Have one last look from a couple of meters away to check it is lined up correctly, then trace over the lettering with a Uni-ball Posca pen on to the Perspex. For my example, I used a fine marker for the names and a broad marker for the title.

 Leave to dry thoroughly before removing the paper sheet/s from the back of the Perspex. You might also need to carefully wipe away any finger marks you may have left on the sheet.

 Place your finished product on an easel or prop it up on a table surrounded by floral displays as a spectacular handmade feature.

Be Our Guest

Table One

Grandma
Grandpa
Nanna

Table Two

Bride
Groom
Mr James

Table Three

Maureen West
John Read
Diane Bishop

Templates

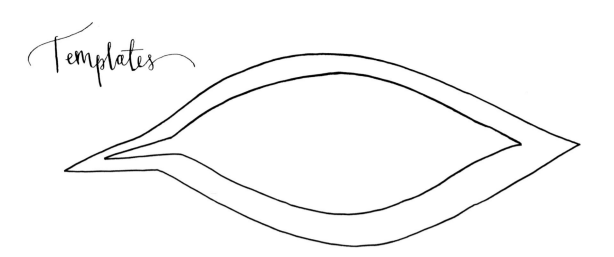

Using tracing or layout paper, trace these templates and cut out both feather shapes. Stick these shapes to a piece of stiff card and cut out to give you a large and small base feather template to create the gift tags on page 142.

This template will fit on a standard C6-sized envelope. Trace or photocopy onto a stiff piece of card and cut out the shaded sections with a craft knife to create an envelope-lettering guide.

Enlarge these cake topper templates on a photocopier or scanner at 150 per cent and cut round them to give you a basis for the cake toppers on page 174, or use them as inspiration for your own scroll shapes.

A creative lettering challenge

So I'm leaving you now to go on your own inky adventures. Thank you for choosing this book to begin your love affair with lettering. Just before you go, I know it can be hard to commit to practising at the end of a busy day when there are so many digital distractions all around us, and I don't want you to lose your lettering flow. So, here are four little creative challenges I'd love to set you to help you to continue your learning and share your new skills with your friends and family.

Over the next month I challenge you to…

- Scroll through your phone and find the first person beginning with 'R' in your contacts. Write them a short letter using your pointed pen and ink in the modern calligraphy style to tell them about your new hobby.
- Copy out the lyrics of your favourite childhood song.
- Write a short review of your favourite book and fold it inside your copy of it for the next person who reads it to find.
- See how enticing you can make a regular shopping list by creating a composition using several different styles of lettering.

Share your work, experiments and finished projects with us at @Pavilionbooks and @BettyEtiquette.

Suppliers

For ink and nibs:
Scribblers
www.scribblers.co.uk

Cass Art
66–67 Colebrooke Row
London
N1 8AB
www.cassart.co.uk

Betty Etiquette
www.bettyetiquette.co.uk

Blots Pen & Ink Supplies
14 Lyndhurst Avenue
Manchester
M25 0GF
www.blotspens.co.uk

Penman Direct
64 Hills Road
Saham Toney
Thetford
Norfolk IP25 7EN
www.penmandirect.co.uk

Fred Aldous Ltd
37 Lever St
Manchester
M1 1LW
www.fredaldous.co.uk

L. Cornelissen
105 Great Russell St
London
WC1B 3RY
www.cornelissen.com

London Graphics Centre
16–18 Shelton Street
London
WC2H 9JL
www.londongraphics.co.uk

Paper and Ink Arts
113 Graylynn Drive
Nashville, TN 37214
www.paperinkarts.com

John Neal Bookseller
1833 Spring Garden Street, First Floor
Greensboro, NC 27403
www.johnnealbooks.com

Dick Blick
7301 West Beverly Boulevard
Los Angeles, CA 90036
www.dickblick.com

JetPens.com
2050 Gateway Place, Suite 100
San Jose, CA 95110
www.jetpens.com

For vintage postage stamps:
Stanley Gibbons
399 Strand
London
WC2R 0LX
www.stanleygibbonsplc.com

Champion Stamps
432 West 54th Street
New York, NY 10019
www.championstamp.com

For rubber stamps:
The English Stamp Company
Worth Matravers
Dorset BH19 3JP
www.englishstamp.com

Rubber Stamps Unlimited, Inc.
334 South Harvey St.
Plymouth, MI 48170
www.thestampmaker.com

Hunt out nibs, card supplies and
vintage china on Ebay and Etsy.

GREAT PLACES FOR INKY
ADVENTURES

Victoria and Albert Museum
Cromwell Road
London
SW7 2RL
www.vam.ac.uk

British Museum
Great Russell Street
London
WC1B 3DG
www.britishmuseum.org

Fitzwilliam Museum
Trumpington Street
Cambridge
CB2 1RB
www.fitzmuseum.cam.ac.uk

Ditchling Museum of Art & Craft
Lodge Hill Lane
Ditchling
East Sussex BN6 8SP
www.ditchlingmuseumartcraft.org.uk

To see the Book of Kells:
Trinity College Dublin
College Green, Dublin 2, Ireland
www.tcd.ie

The Met Fifth Avenue
1000 Fifth Avenue
New York, NY 10028
www.metmuseum.org

**Hill Museum & Manuscript
Library**
2835 Abbey Plaza
Saint John's University
Collegeville, MN 56321–7300
www.hmml.org

**The Richard Harrison
Collection**
San Francisco Public Library
100 Larkin Street
San Francisco CA 94102-4733
www.sfpl.org

Letterform Archive
1001 Mariposa Street #307
San Francisco, CA 9410
www.letterformarchive.org

Acknowledgements

I am indebted to the amazing team at Pavilion Books for this opportunity. My editor Nicola Newman's expert guidance and encouragement has been invaluable on this creative journey. Many thanks to designer Ana Teodoro who has brought this book to life, Michael Wicks for his beautiful photography and to Tina Persaud for being the catalyst for the whole fantastic project.

Big thanks go to all the people that have attended a workshop with me over the last three years. Your feedback, ideas and willingness to jump into learning a new skill are endlessly inspiring.

To family: Ma and Pa Cahill, for ramshackle houses full of creativity, adventure and love. Thanks to my ridiculously talented siblings Caitlin, Fred and Patrick for endless laughter-filled days of crayon collaborations and newspaper forests. And thanks to Mum Roots for everything you do for us.

To such dear friends who have been cheerleaders, bakers, guinea pigs and constructive critics. I can't name you all here, but just know that I'm coming for you with great thanks (and cake) and I'm so ready to return the support you've shown me.

Finally, thank you to my husband, David, for his wisdom, patience and ability to make me run towards the exciting but scary stuff, not away from it any more.

About the author

Rebecca Cahill Roots has been putting pen to paper since childhood. Her passion for lettering began with thank-you cards around the family kitchen table and has developed into an award-winning creative business, Betty Etiquette, established in 2014. From her home studio she designs her stationery range and produces lettering for magazine editorials, weddings, branding and promotional material.

Alongside applying her hand-lettering techniques to stationery and private commissions, Rebecca teaches modern calligraphy and brush lettering workshops, from private tuition for celebrity brides-to-be to large-scale corporate events. Her inky adventures have taken her to a host of magical venues including Liberty and the Victoria and Albert Museum.

Rebecca lives with her family in South London and can usually be found in dungarees with ink in hand and an emergency biscuit tucked in her pocket. She is a passionate advocate for hand-made craft and creative small business in Great Britain.

www.bettyetiquette.co.uk

Index